POSTER BOOK

Introduction by
Adrian Rigelsford

BOXTREE

First published in Great Britain in 1995 by Boxtree Limited, Broadwall House, 21 Broadwall, London SE1 9PL

Dr. Who diamond logotype © BBC 1973. The Daleks © BBC / Terry Nation 1963. Licensed by BBC Worldwide Limited.
Dr. Who and Dalek word mark, device mark and logotype are trade marks of the British Broadcasting Corporation and are used under license.
All character names as they appear in the BBC television series Dr Who. Licensed by BBC Worldwide Ltd.

Copyright © Adrian Rigelsford / Luke Books
Licensed by BBC Wordwide Ltd.

Designed by Design 23

Printed and bound in Great Britain by
Butler & Tanner Ltd, Frome and London

A CIP catalogue entry for this book is available from the British Library.

1 2 3 4 5 6 7 8 9 10

ISBN: 0 7522 0795 4

With thanks to Gary Russell, Marcus Hearn, Gary Gillett, Scott Gray, Clive Banks, Simon Carter, Paul Laurence, Caroline Batten and, from Luke Books, Gary Shoefield, Sharon Shoefield, and Paul Shoefield.

Doctor Who
Thirty Years of Time Travel

As the cold winter evening closed in on November 23rd 1963, the programming on BBC Television returned to normal after hours of continual news coverage from the USA where the charismatic American President, John F Kennedy, had been assassinated the day before. At 5.25 pm a new science fiction adventure series began. There had been little publicity heralding its arrival, and nobody could have predicted the impact that *Doctor Who* would have on the young and old alike . . . who would even have dared to dream that its success would span thirty years into the future?

It was a time when there was an air of excitement surrounding anything to do with outer space. So, the concept of a cantankerous old man, exiled from his own world with his granddaughter, and their voyages through time and space with a pair of young teachers from Earth, certainly hit the right nerve. The programme was an instant hit, and quickly became a national institution.

The TARDIS (the initials for the Doctor's time machine, which were quickly explained as 'Time And Relative Dimensions In Space'), with its hexagonal control room and console, pulsating lights and intricate apparatus, was an amazing feat of technical design for its time. The exterior of the craft was somewhat easier to realise. Its 'Chameleon Circuit' which should have enabled the TARDIS to change its outer appearance and blend in with whatever environment it landed in, was jammed, and so the vessel's permanent hull was a battered blue police box. This is, perhaps, the closest thing the series has to a trademark. But it was the impact of the programme's monsters which guaranteed that *Doctor Who* was here to stay.

By the end of the third year of production, a veritable army of creatures had confronted the Doctor and his companions; Zarbi, Menoptera, Sensories, Rills the Voord, Mechanoids and, of course, there had been numerous encounters with the Daleks. It was at that time that the Production Team had to deal with an almost impossible problem when William Hartnell made it quite clear that he wanted to move on. How could *Doctor Who* possibly continue without the Doctor?

The mythology surrounding *Doctor Who* has grown steadily over three decades, and during that time a steady stream of facts have been revealed, the most significant of which is that when old age or illness takes its toll on the Doctors' bodies, they have the ability, barring fatal accidents, to regenerate, giving them up to thirteen lives and different personalities. It is this fact that has allowed the programme to run for so long, with seven different actors having played the Doctor to date.

William Hartnell's Doctor was a grandfather-figure who could be as abrupt as he could be kindly. And, nobody was prepared for what followed.

Patrick Troughton's sudden arrival as the Doctor was a shock to both companions and public alike. But Troughton stayed till the end of the sixties, and those who were reluctant to accept him at first were soon won over by his whimsical charm. It was during Patrick Troughton's reign that the Sonic Screwdriver was first introduced, but it was more of a toy that he liked to show off than the weapon and tool it would be for the next three Doctors.

Then, for five years, Jon Pertwee's Doctor called on all manner of gadgets and equipment to do battle with aliens invading Earth. But after defeating a variety of monsters, from Axons to Autons and Sea Devils to Sontarans, it was a Giant Spider that got him in the end! But his life was saved by another Time Lord, allowing Tom Baker to step in as the fourth Doctor.

Seven years as the Doctor lay ahead for Baker, the longest period in the role for any of the Doctors. In one of his never-ending fights to save the Universe, the fourth Doctor fell from a radar tower, inducing his regeneration into the fifth Doctor, Peter Davison.

As the youngest Doctor to date, Davison dressed with the air of Victorian cricketer. There was a streak of inherent bravery in his character and it was the fight to save his last companion, Peri, that brought about the fifth Doctor's demise.

The sixth Doctor, Colin Baker, is the only actor to have appeared previously in the series, as Commander Maxil in Davison's 'Arc of Infinity', before taking the role of the new Doctor.

Injured in a crash induced on the TARDIS in mid-flight, the regeneration from sixth to seventh Doctor was as dangerous as it was unstable, leading to the reign of Sylvester McCoy, the most recent Time Lord to date. McCoy brought the unpredictable quality back to the Doctor, which was last felt during Hartnell's era.

The Doctor was last seen heading off into the sunset with his current companion, Ace. Whatever the future holds, the Doctor will always be exploring it, accompanied by one of his fellow travellers . . .

Fellow Travellers and Guests on Board

Companion, assistant, accomplice – call them what you will – there have been close to thirty whose lives have been changed beyond recognition, in some cases fatally, by travelling with the Doctor. It became a cliché to say that all a 'companion' was required to do was scream and look terrified, and in many cases this was true, but it was an essential part of the programme. Whether it was Susan Foreman or Polly, Victoria Waterfield or Zoe Herriot, Jo Grant or Sarah Jane Smith – the conviction behind their terrified expressions was what the audience

wanted to see.

The companions have been devastatingly intelligent, with Romana Mark I and II easily being a mental equal to the Doctor. They've been headstrong – and towards the latter years they've been dangerous, with Leela and Ace certainly more than capable of fighting back. But not all the fellow travellers have been female.

Ian Chesterton first blustered into the TARDIS fearing for the safety of his pupil, Susan Foreman. Ben Jackson was a sailor on voyages he couldn't comprehend, and Jamie was a refugee from Culloden.

Through the 1970s the men of the UNIT stood alongside the Doctor. Led by Brigadier Lethbridge-Stewart, Mike Yates and Sergeant Benton were loyal to the cause, and Harry Sullivan left his post as UNIT's Medical Officer to travel with the fourth Doctor for a brief time.

Actors have always clamoured to appear in the series. In the list of stars you'll find the names of John Cleese, Windsor Davies, Brian Blessed, Richard Briers, Rula Lenska, Beryl Reid, Dinsdale Landen, Kate O'Mara . . . the list is practically endless.

Of all the companions that have ever appeared in the series, the most popular was surely K9 – a fully automated special effect, voiced by John Leeson (and later David Brierly), who stole the hearts of the nation.

The Monstrous Menaces

Wherever the Doctor travelled, whatever situation he landed in, there was always an edge of expectancy from the audience, waiting to see what monster would be the particular foe for that adventure.

Among the dozens that the writers dreamt up, a distinct list of favourites emerged over the years: the Cybermen, the Ice Warriors, the Yeti, the Silurian and Sea Devils, the Zygons and Kraals are simply a few.

The Success Story

Doctor Who has a worldwide audience in excess of 110 million, with the series reaching over 60 countries, from Australia to Zimbabwe. At thirty years, it's not only the longest running science fiction series, but it's now one of the longest running television series of any kind.

There's been *Doctor Who* wallpaper, model kits, board games, calendars, badges, sweets – all under license from BBC Enterprises.

A permanent exhibition of props and monsters from the series was established at Longleat House in Wiltshire in 1973 and is still running today, and lecture tours by production personnel and actors regularly go round the country, detailing all aspects of the series' history.

And the *Doctor Who* titles released by BBC Video always enter the top ten. The market for the Time Lord's adventures is growing all the time . . .

The Doctor Who Time Line

1963	**William Hartnell appears as the first Doctor**
1963	**The Daleks appear in the second adventure**
1965	***Doctor Who and the Daleks* movie starring Peter Cushing**
1966	**Patrick Troughton appears as the second Doctor**
1970	**Jon Pertwee appears as the third Doctor in colour**
1973	**'The Three Doctors' starring Hartnell, Troughton and Pertwee**
1973	**BBC Enterprises' *Doctor Who* exhibition opens at Longleat House**
1974	**Tom Baker appears as the fourth Doctor**
1975	***Doctor Who* Appreciation Society formed**
1977	**First *Doctor Who* convention held in London**
1979	***Doctor Who* magazine first published**
1979	**First overseas filming in Paris**
1980	***Doctor Who* convention in Los Angeles**
1980	**Peter Davison appears as the fifth Doctor**
1983	**Location filming in Amsterdam for the 20th series**
1983	**'The Five Doctors' special is screened in UK and USA**
1983	**Four of the Doctors appear at a convention in Chicago**
1984	**Colin Baker appears as the sixth Doctor**
1984	**Location filming in Lanzarote, Canary Islands**
1985	**Location filming in Seville**
1986	**Touring exhibition in USA**
1987	**Sylvester McCoy appears as seventh Doctor**
1989	**The final broadcast story to date is screened**

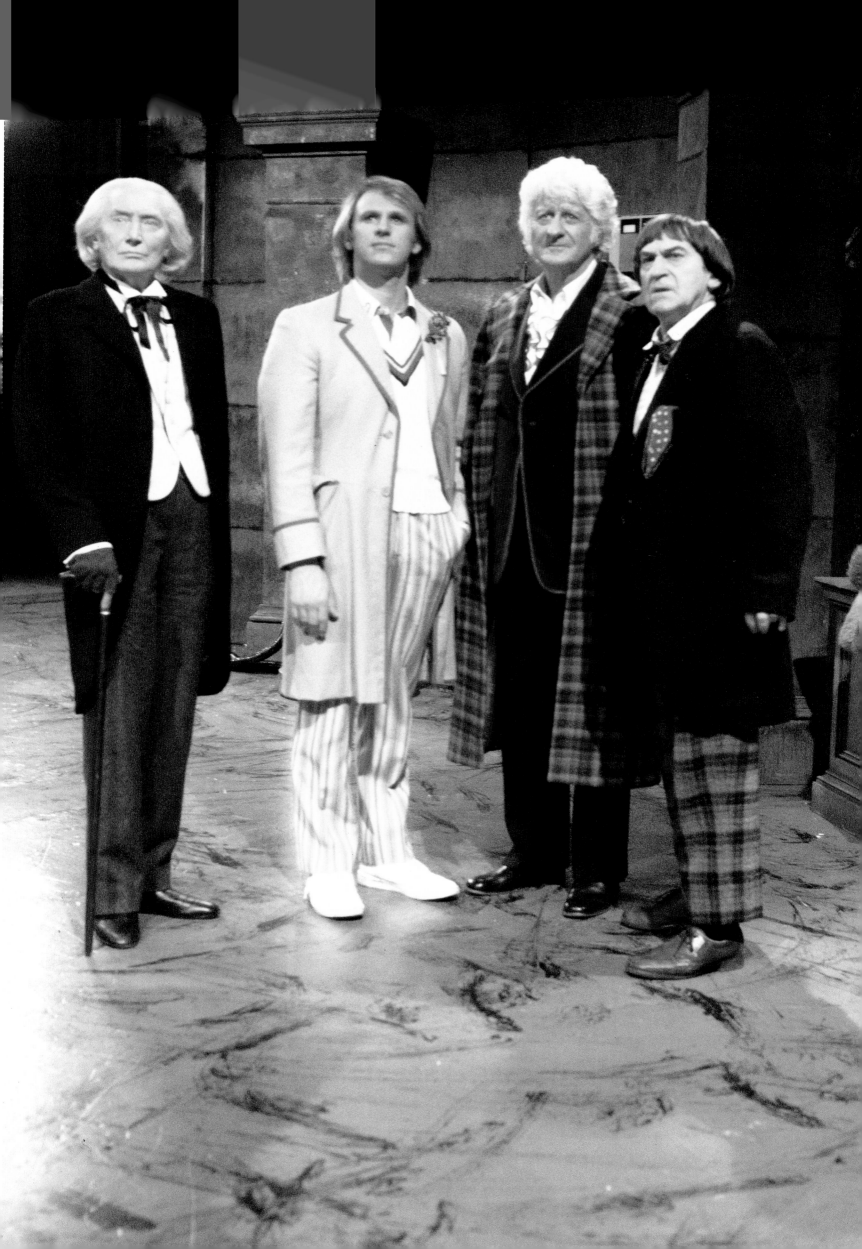

Doctor Who - The Five Doctors

The Doctors – Richard Hurndall taking over from the late William Hartnell as the first, Peter Davison as the fifth, Jon Pertwee as the third and Patrick Troughton as the second. Brought together in the Tomb of Rassilon at the climax of the programme's 20th Anniversary Special.
Originally broadcast November 25th 1983.

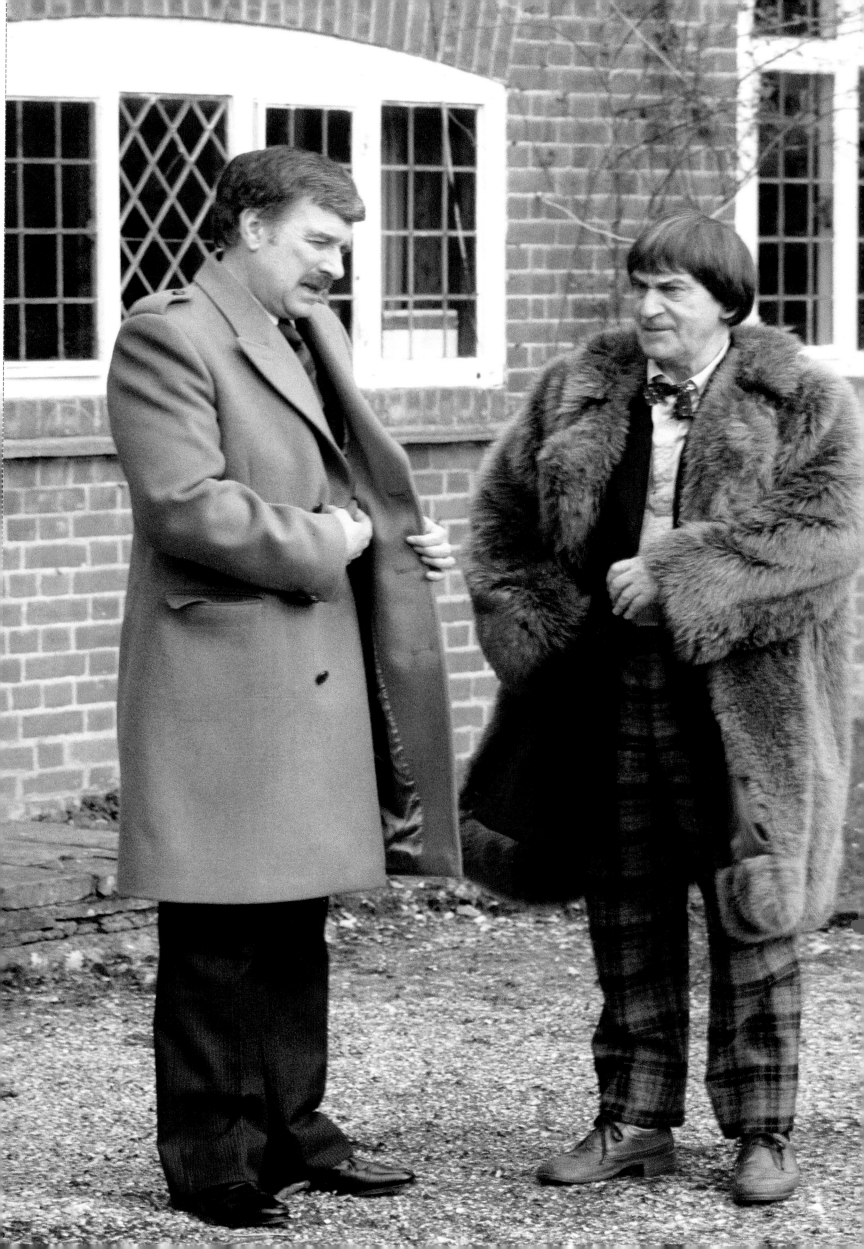

Doctor Who - The Five Doctors

Nicholas Courtney as Brigadier Lethbridge-Stewart and Patrick Troughton as the second Doctor standing outside the UNIT Headquarters, with the Time Lord arriving unexpectedly to hear a speech due to be given by his old friend.
Originally broadcast November 25th 1983.

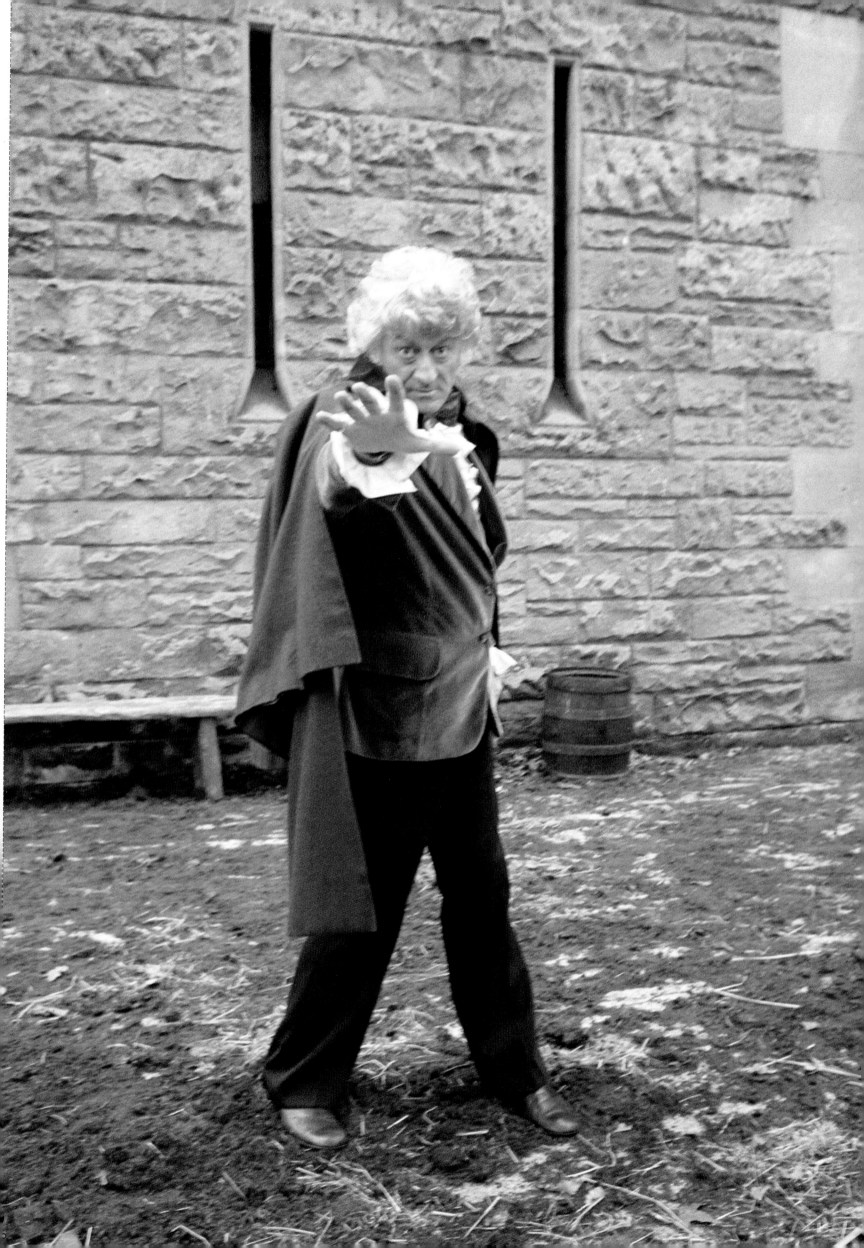

Doctor Who - The Time Warrior

Jon Pertwee as the third Doctor, standing in the grounds of
Irongron's castle in medieval England. In reality, the location
used was Peckforton Castle in Cheshire.
Originally broadcast December 15th 1973 - January 5th 1974.

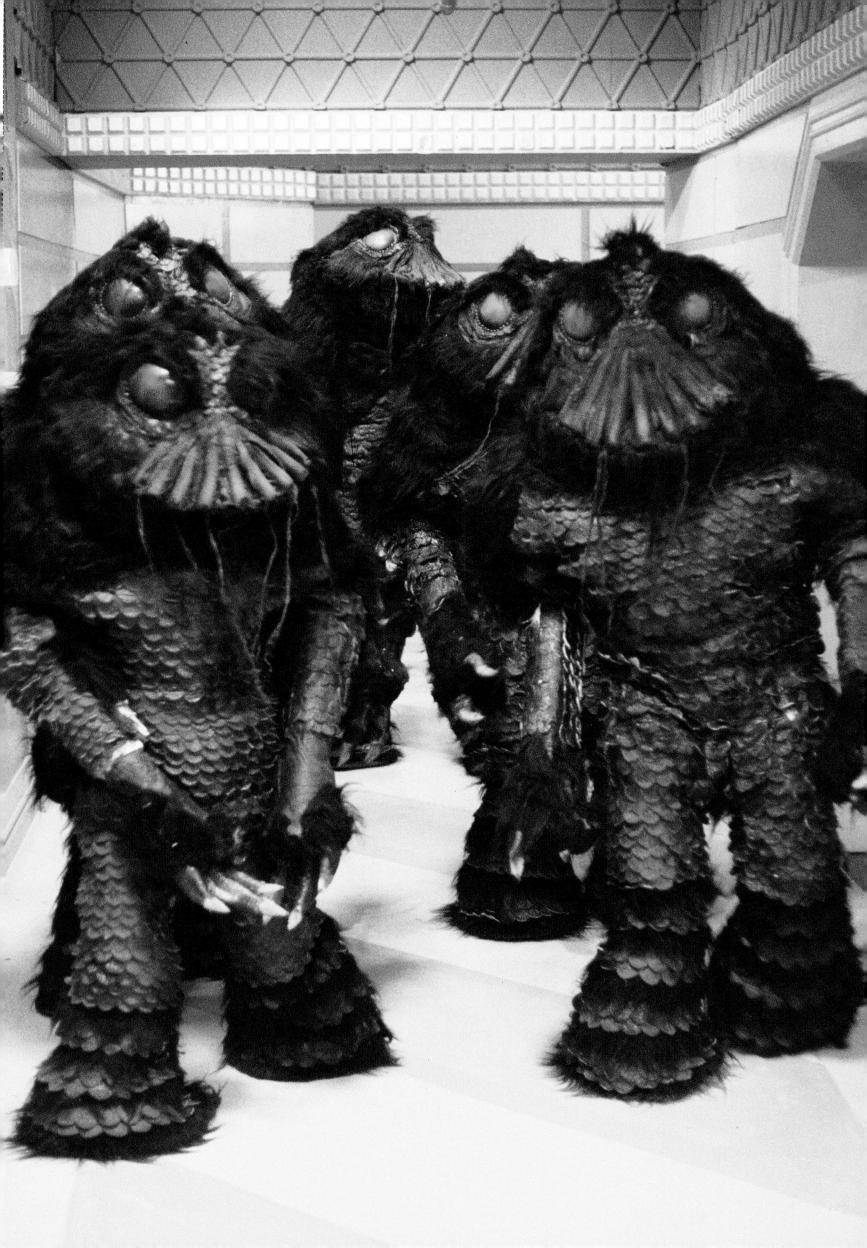

Doctor Who - Nightmare of Eden

The Mandrels charge through the space liner, the Empress, after escaping from the CET (Continuous Event Transmuter) Machine. When they are killed, their bodies decay into the deadly, addictive drug Vraxoin.
Originally broadcast November 24th - December 15th 1979.

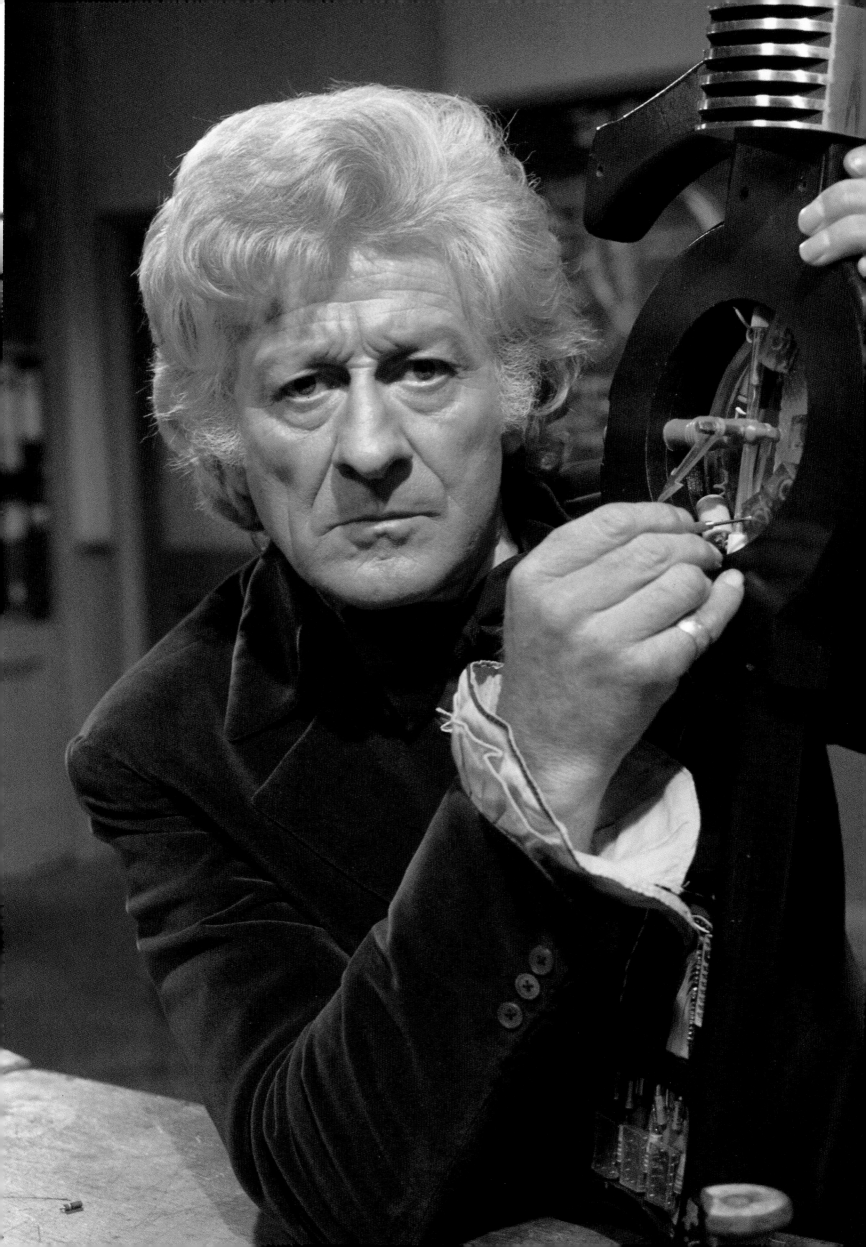

Doctor Who - Invasion of the Dinosaurs

Jon Pertwee as the third Doctor, preparing a piece of equipment to help him capture one of the numerous dinosaurs that have suddenly started to appear across London. Unknown to the Time Lord, he also has to contend with a traitor, working within the UNIT ranks.
Originally broadcast January 12th - February 16th 1974.

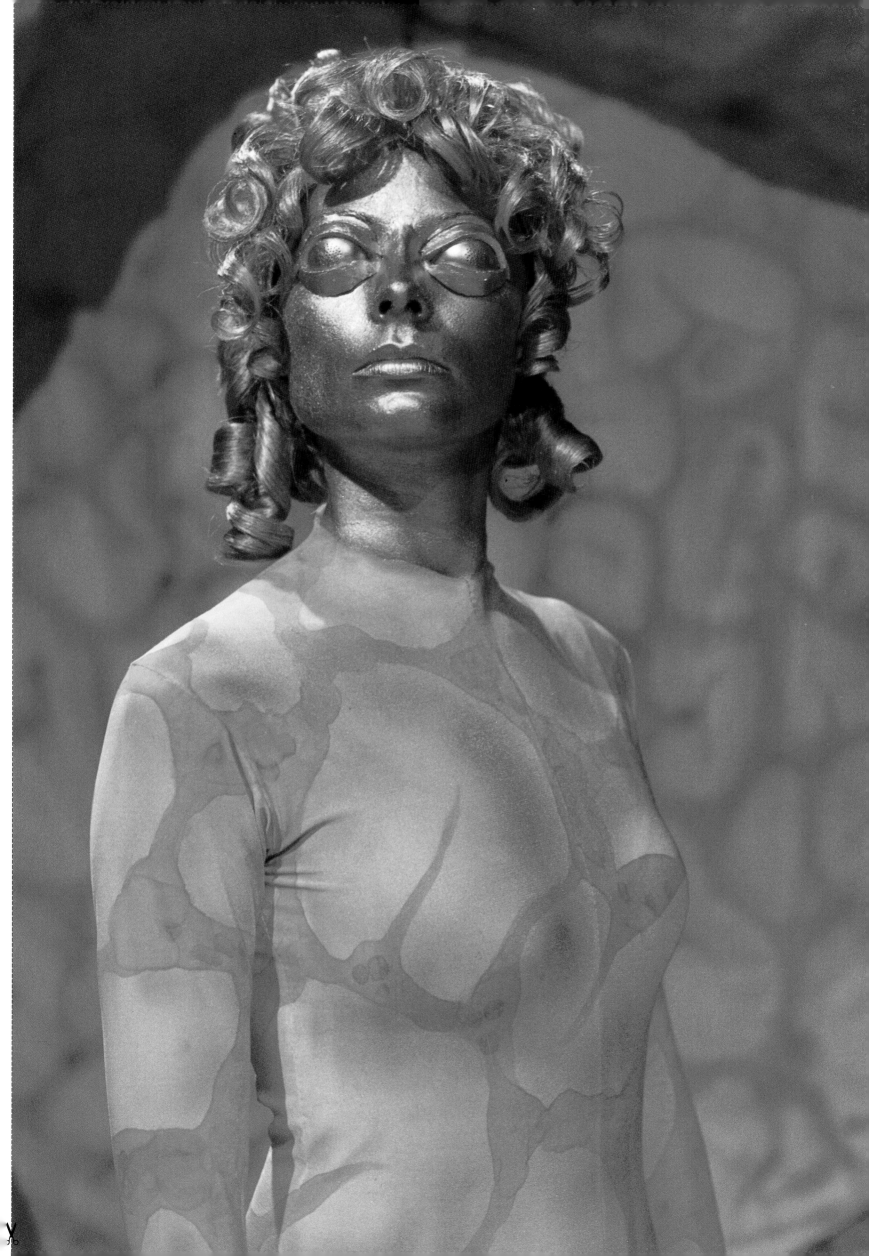

Doctor Who - The Claws of Axos

Patricia Gordino as an Axon Woman, on board their parasitic
alien craft. Their race came in peace to Earth, but their golden
skinned form hides the fact that they are part of an entity intent
on draining the planet of its energy.
Originally broadcast March 13th - April 3rd 1971.

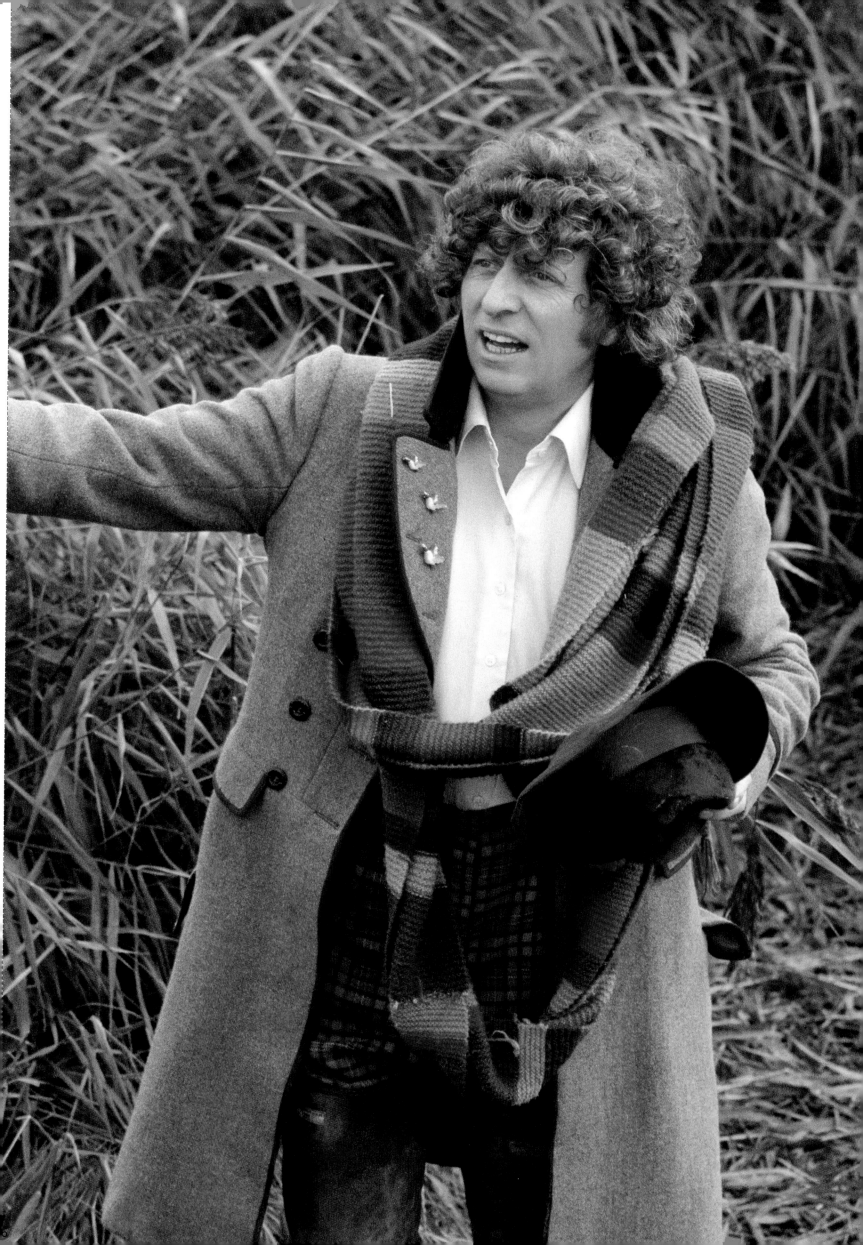

Doctor Who - The Power of Kroll

Tom Baker as the fourth Doctor, filming on location around the
river Alde in Suffolk. The story centred around the quest for the
Fifth Segment of the *Key to Time*.
Originally broadcast December 23rd 1978 - January 13th 1979.

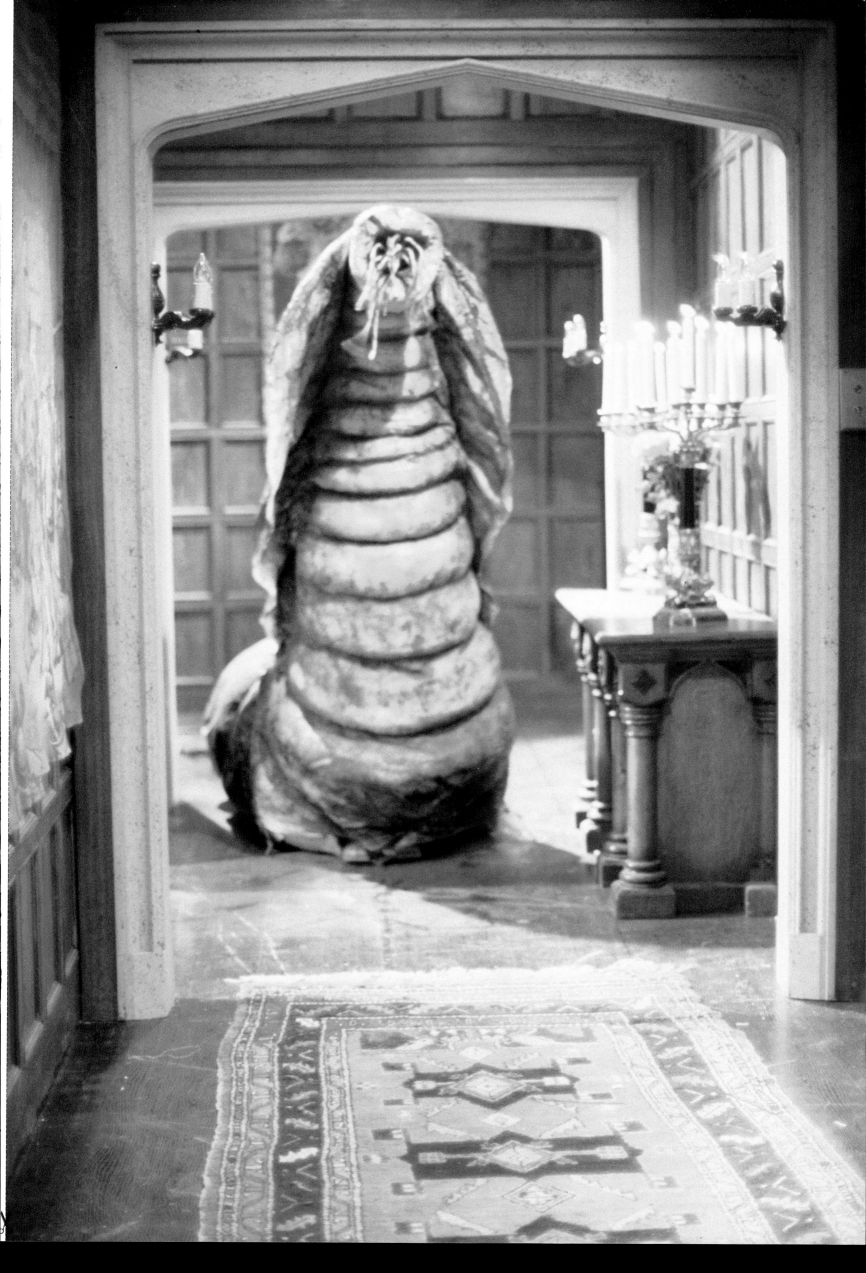

Doctor Who - Image of the Fendahl

A full-sized Fendahleen stalking through the corridors of Fetch
Priory. A Time Scanner brings dormant powers to life in a
12 million year old skull, allowing the powerful Fendahleen Core
to become active again.
Orginally broadcast October 29th - November 19th 1977.

Doctor Who - Image of the Fendahl

A full-sized Fendahleen stalking through the corridors of Fetch
Priory. A Time Scanner brings dormant powers to life in a
12 million year old skull, allowing the powerful Fendahleen Core
to become active again.
Orginally broadcast October 29th - November 19th 1977.

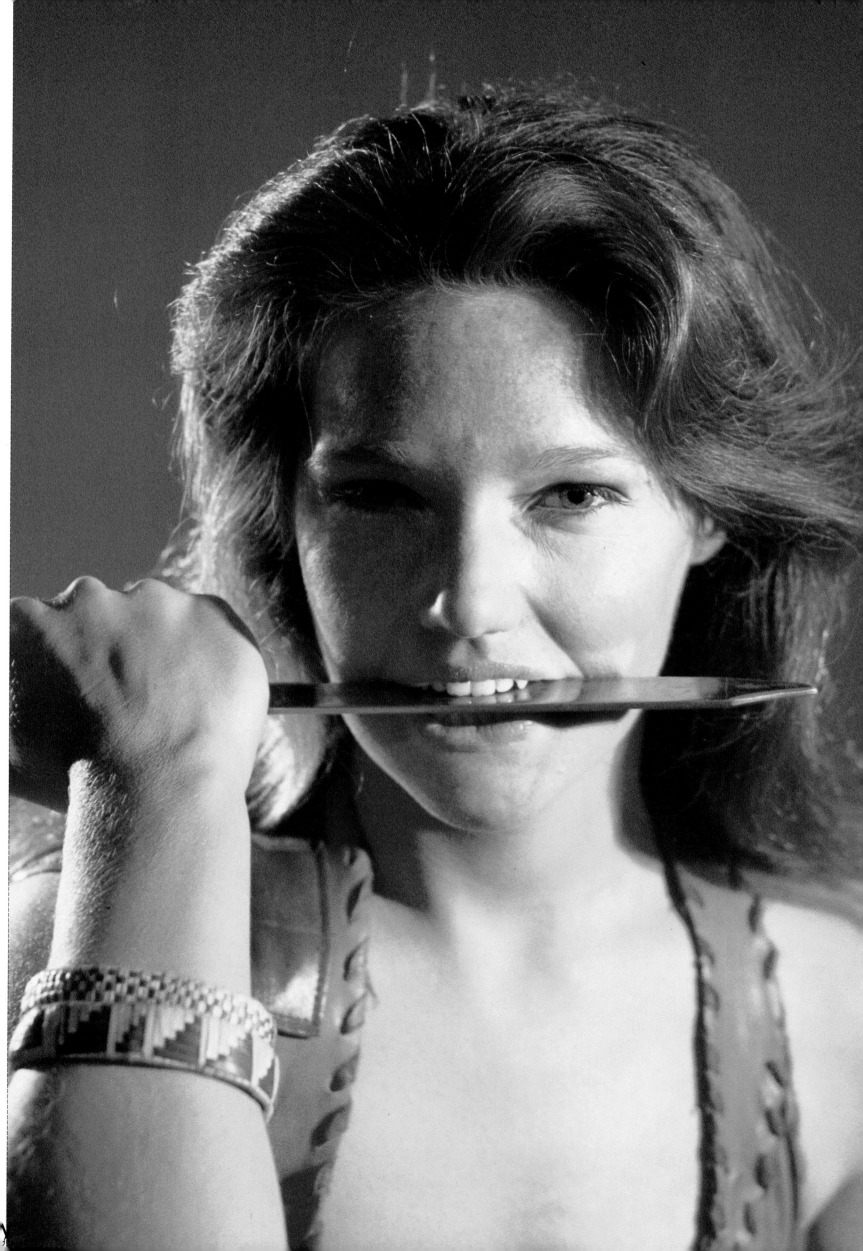

Doctor Who - The Face of Evil

Louise Jameson as Leela, a member of the tribe of savages
called the Sevateem from the planet Xoanon. Tired of her own
world, Leela joined the Doctor to travel in the TARDIS for a total
of nine adventures.
Originally Broadcast January 1st - 22nd 1977.

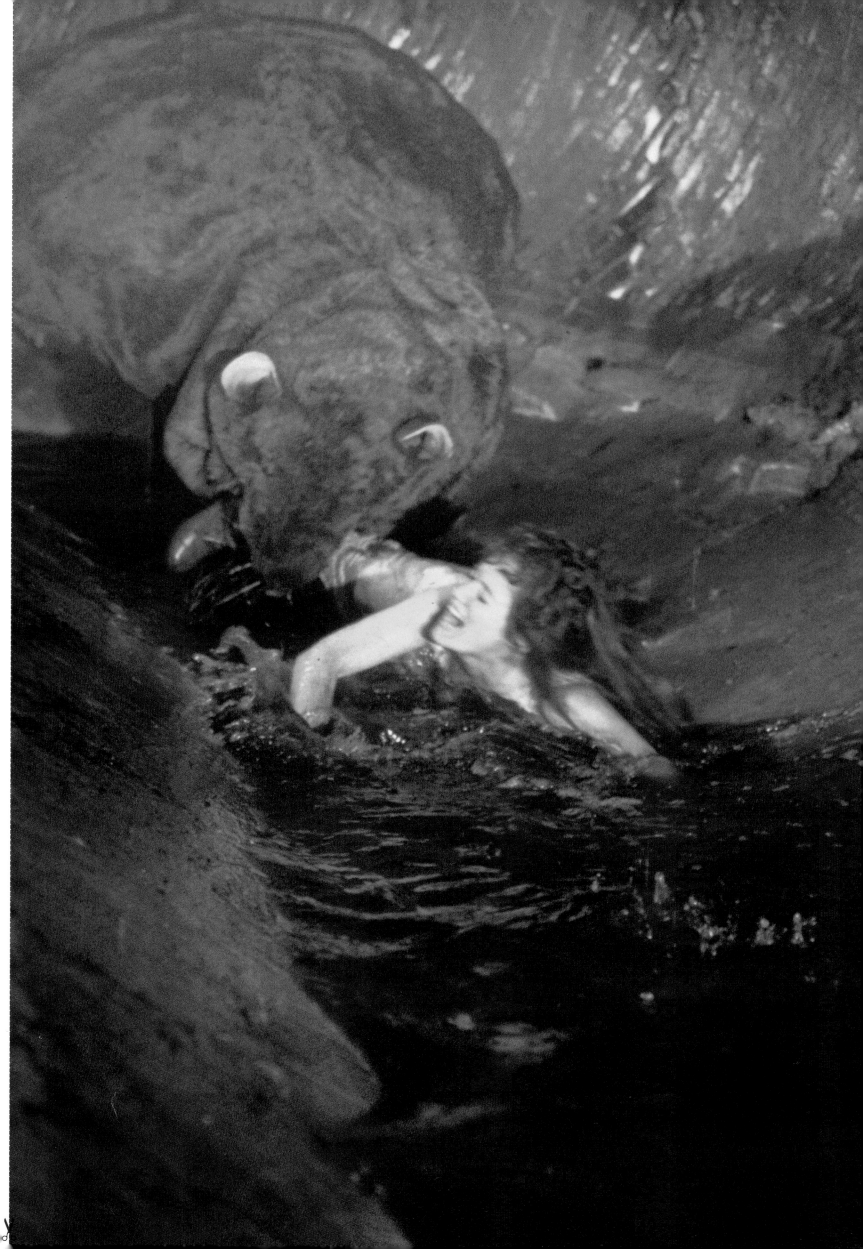

Doctor Who - The Talons of Weng-Chiang

Louise Jameson as Leela, is attacked by one of the giant rats that inhabit the sewers surrounding the lair of Weng-Chiang, an ancient Chinese God. In reality, he's a criminal from the 51st Century called Magnus Greel, brought back by his experiments with time.
Originally broadcast February 26th - April 2nd 1977.

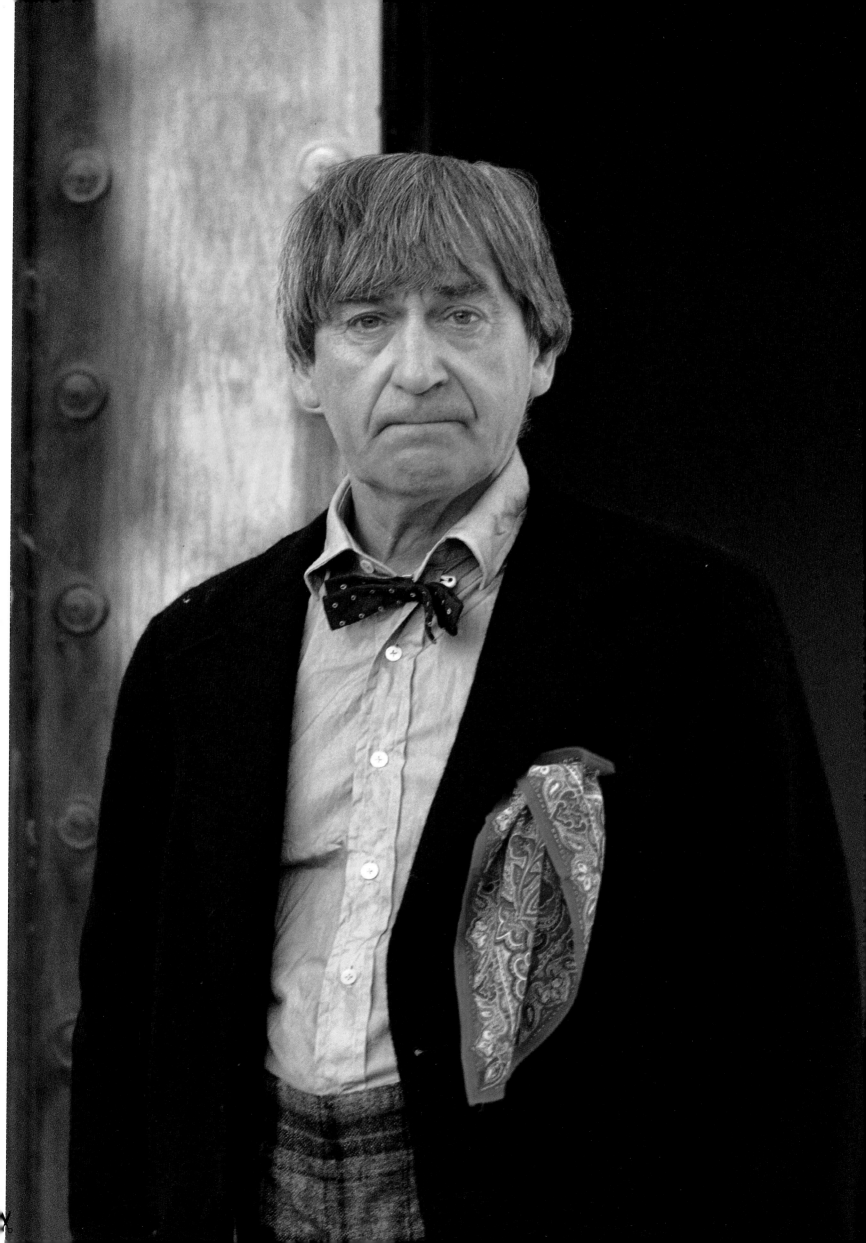

Doctor Who - The Two Doctors

Patrick Troughton as the second Doctor, during the location
filming around the grounds of a villa in Gerena in Spain. After
leaving the programme in 1969, Troughton returned three times
for *The Three Doctors* in 1973, *The Five Doctors* in 1983 and
then this story in 1985.
Originally broadcast February 16th - March 2nd 1985.

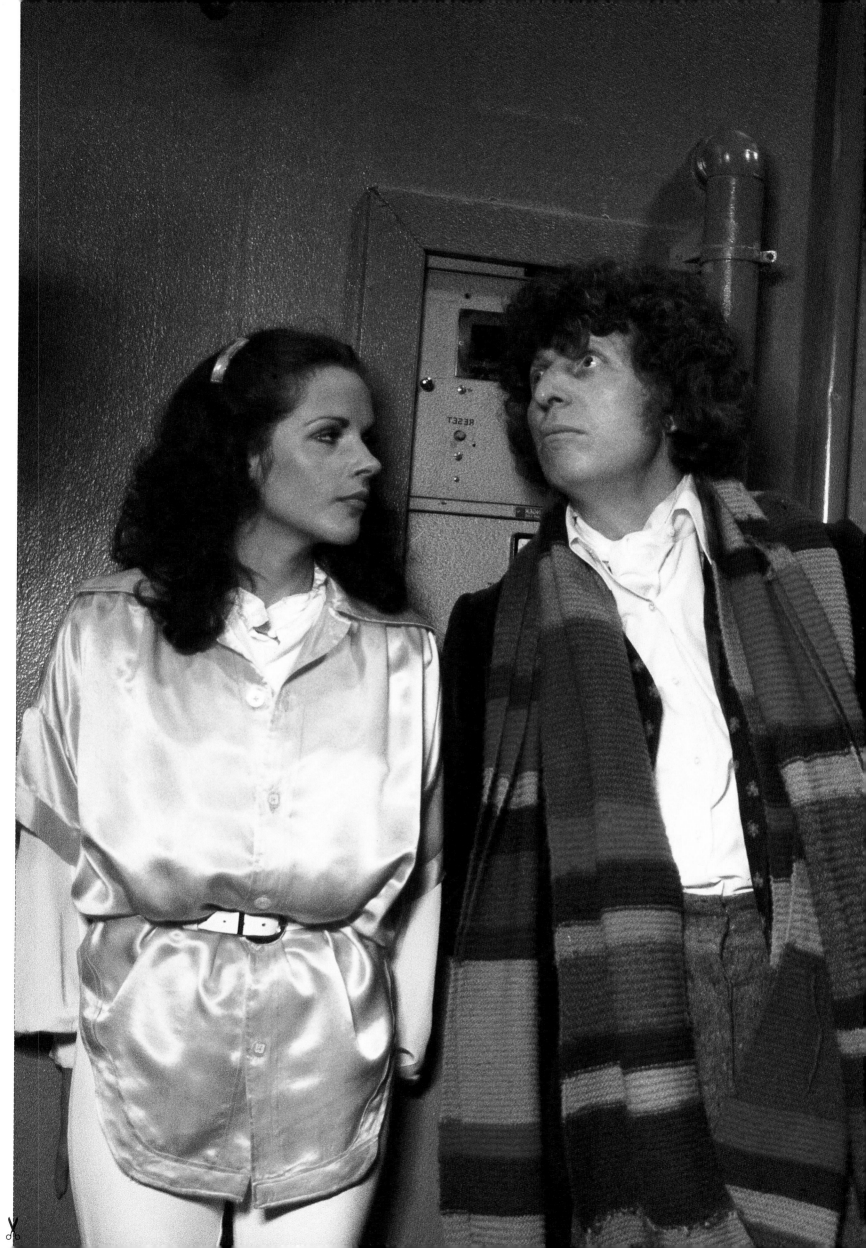

Doctor Who - The Pirate Planet

Mary Tamm as the second incarnation of Romana and Tom Baker as the fourth Doctor, working on the location material for the story at Berkley Power Station in Gloucester. The story was the second to be screened in the *Key To Time* season. *Originally broadcast September 30th - October 21st 1978.*

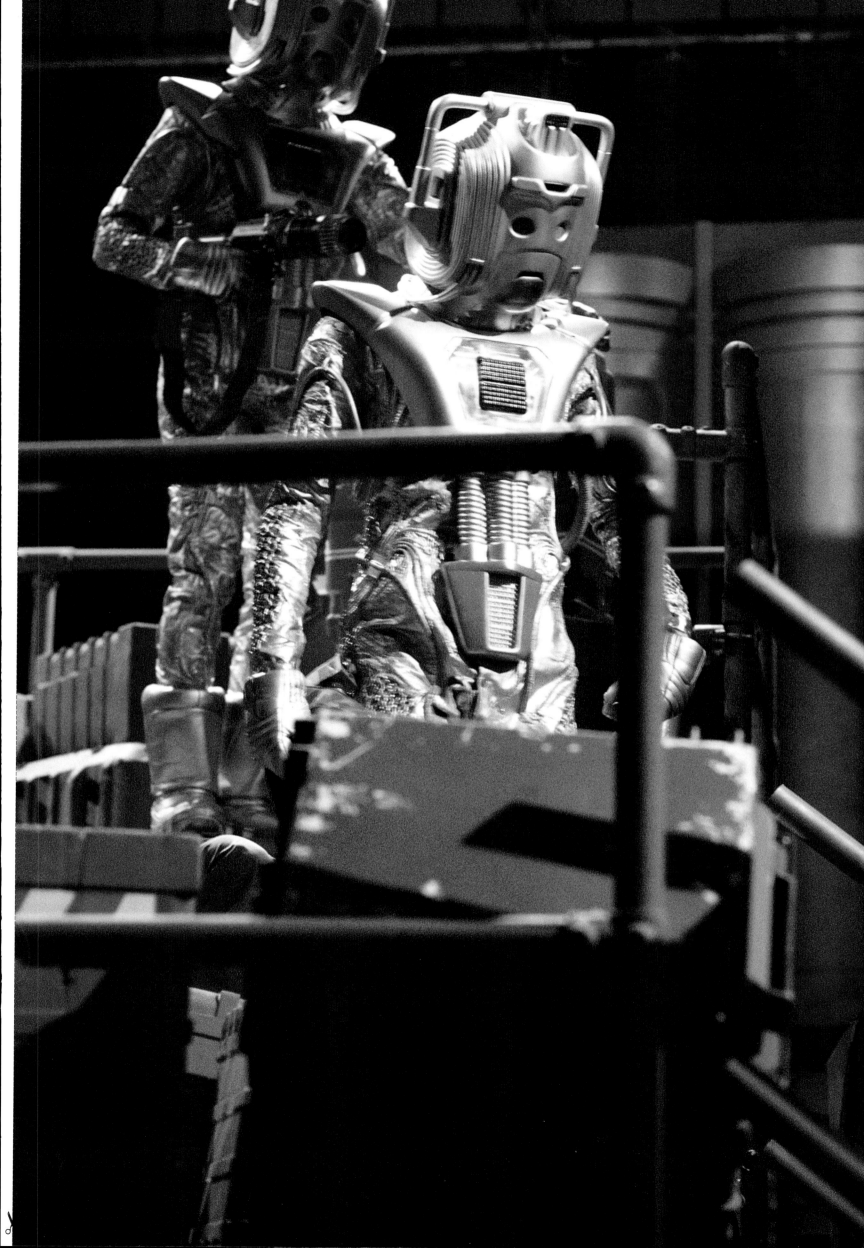

Doctor Who - Earthshock

The Cybermen invade the space freighter in their first appearance in the series for seven years. With suitably updated costumes, they were last seen in *Revenge of the Cybermen* in 1974.
Originally broadcast March 8th - 16th 1982.

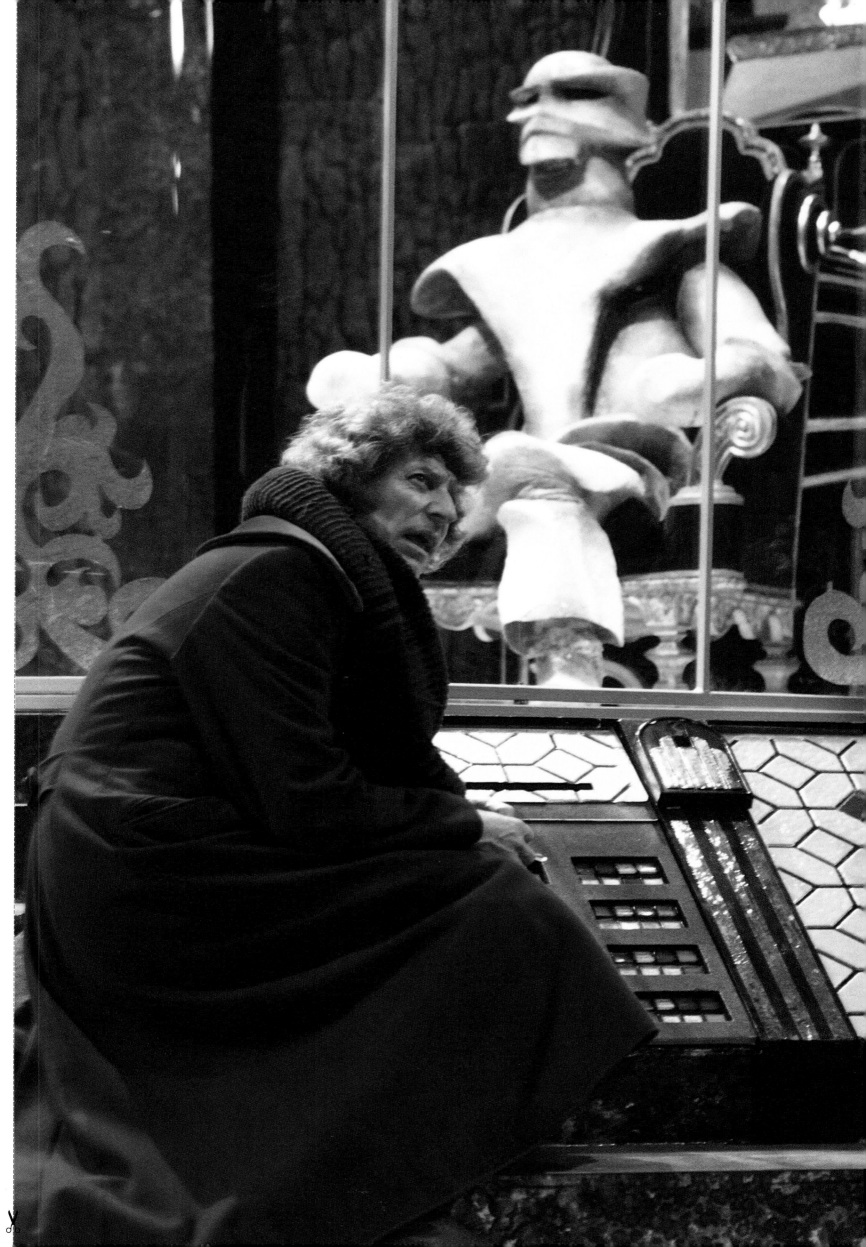

Doctor Who - The Keeper of Traken

Tom Baker as the fourth Doctor in the penultimate story of his seven year run as the Time Lord. The Melkur has taken over the power of the Keeper, and hides the TARDIS of the Master within it's shell.
Originally broadcast January 31st - February 21st 1981.

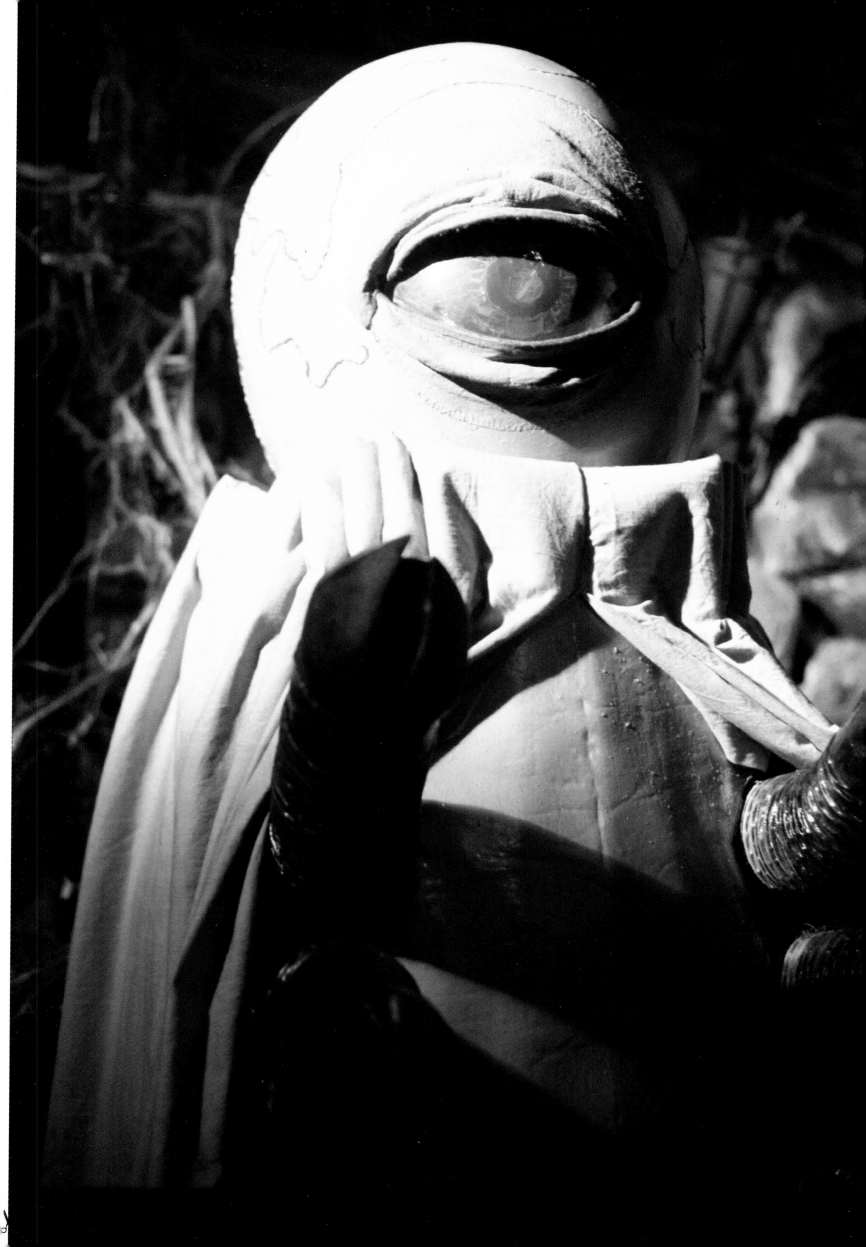

Doctor Who - The Monster of Peladon

Alpha Centuri, an ambassador for the Galactic Federation on the planet Peladon. The multi-limbed creature was played by veteran Doctor Who stuntman, Stuart Fell, while its high-pitched voice was supplied by Ysanne Churchman.
Originally broadcast March 23rd - April 27th 1974.

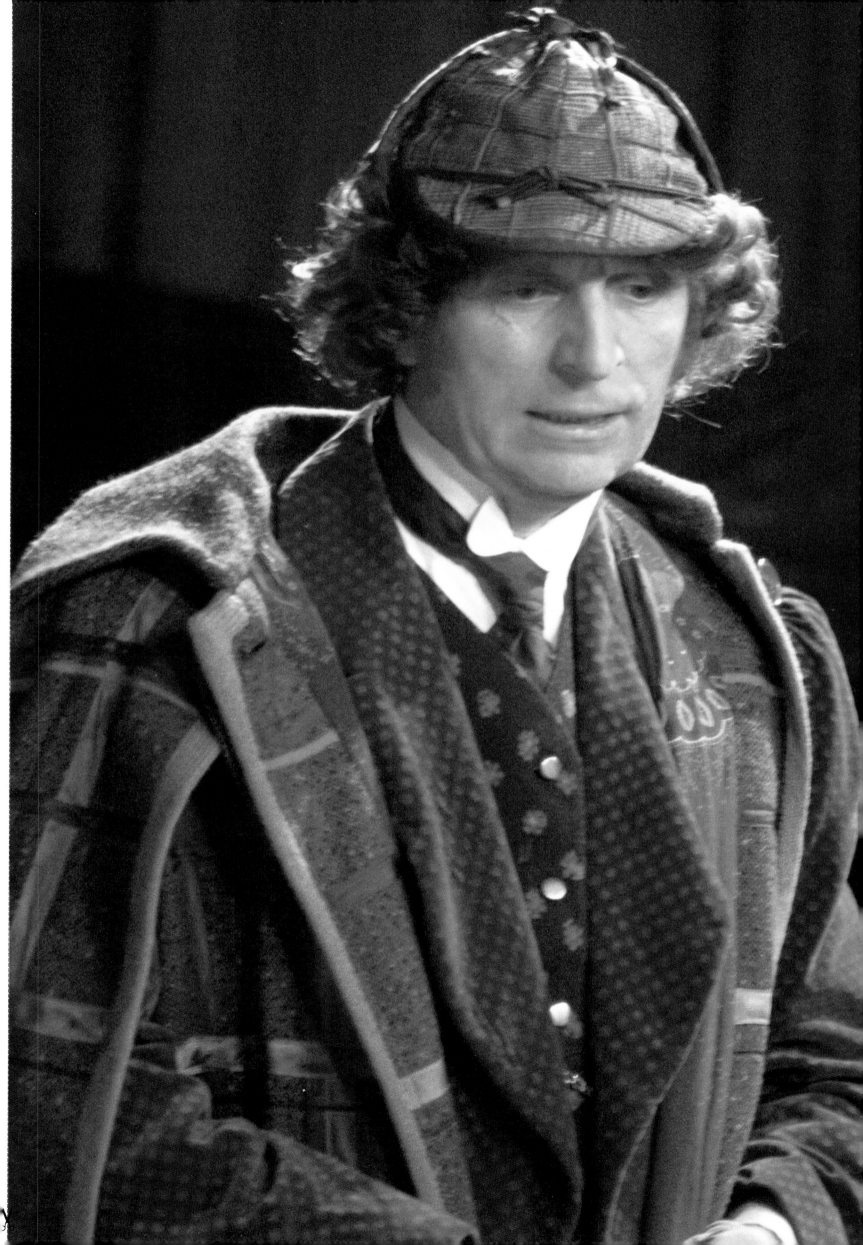

Doctor Who - The Talons of Weng Chiang

Tom Baker as the fourth Doctor, in his Victorian, Sherlock Holmes-
esque costume, figuring out his next move against the war
criminal from the future, Magnus Greel, at the home of Police
Pathologist, Professor Litefoot.
Originally broadcast February 26th - April 2nd 1977.

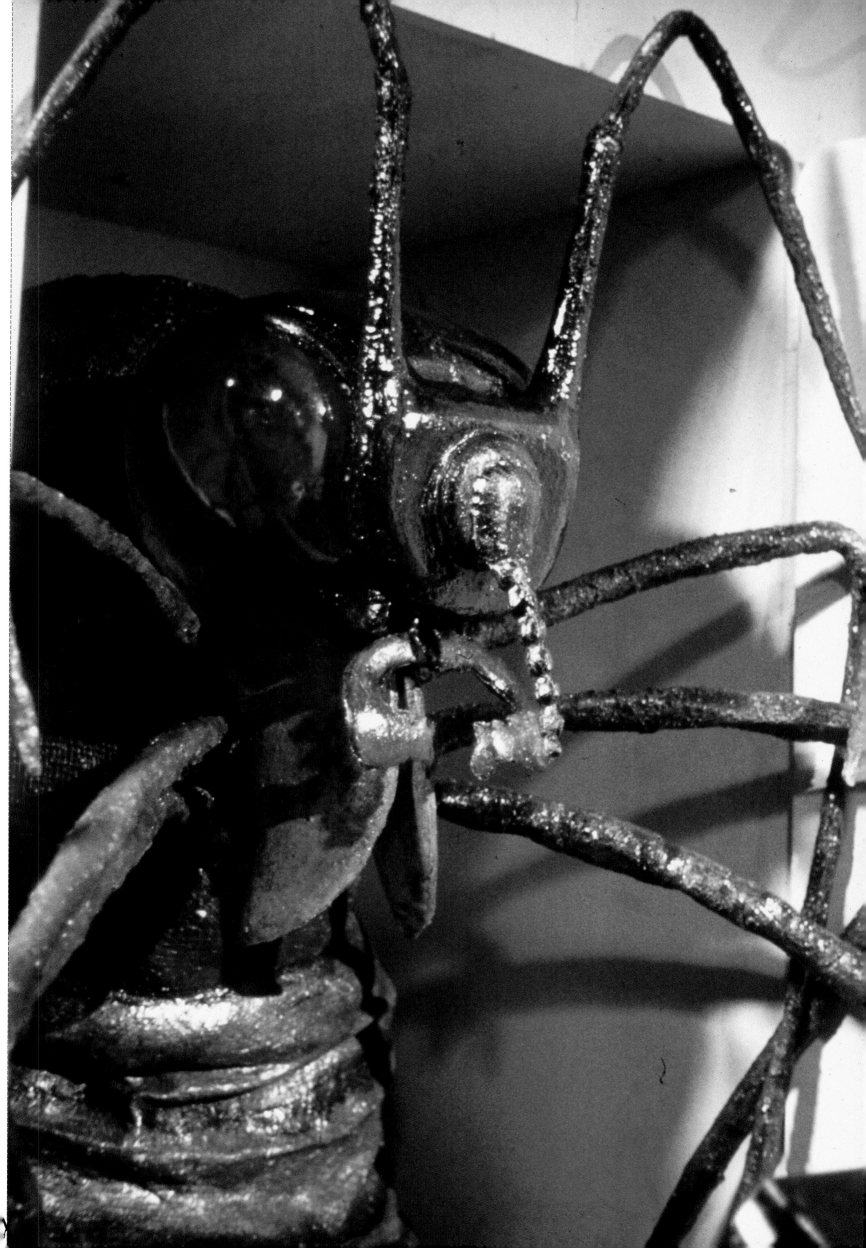

Doctor Who - The Ark in Space

The dead body of the Wirrn Queen, a species of insect that lays it's eggs near food so the larva can feed as it grows. In this case, her last egg was implanted in the sleeping body of one of the humans in cryogenic suspension on the space station Nerva.
Originally broadcast January 25th - February 13th 1975.

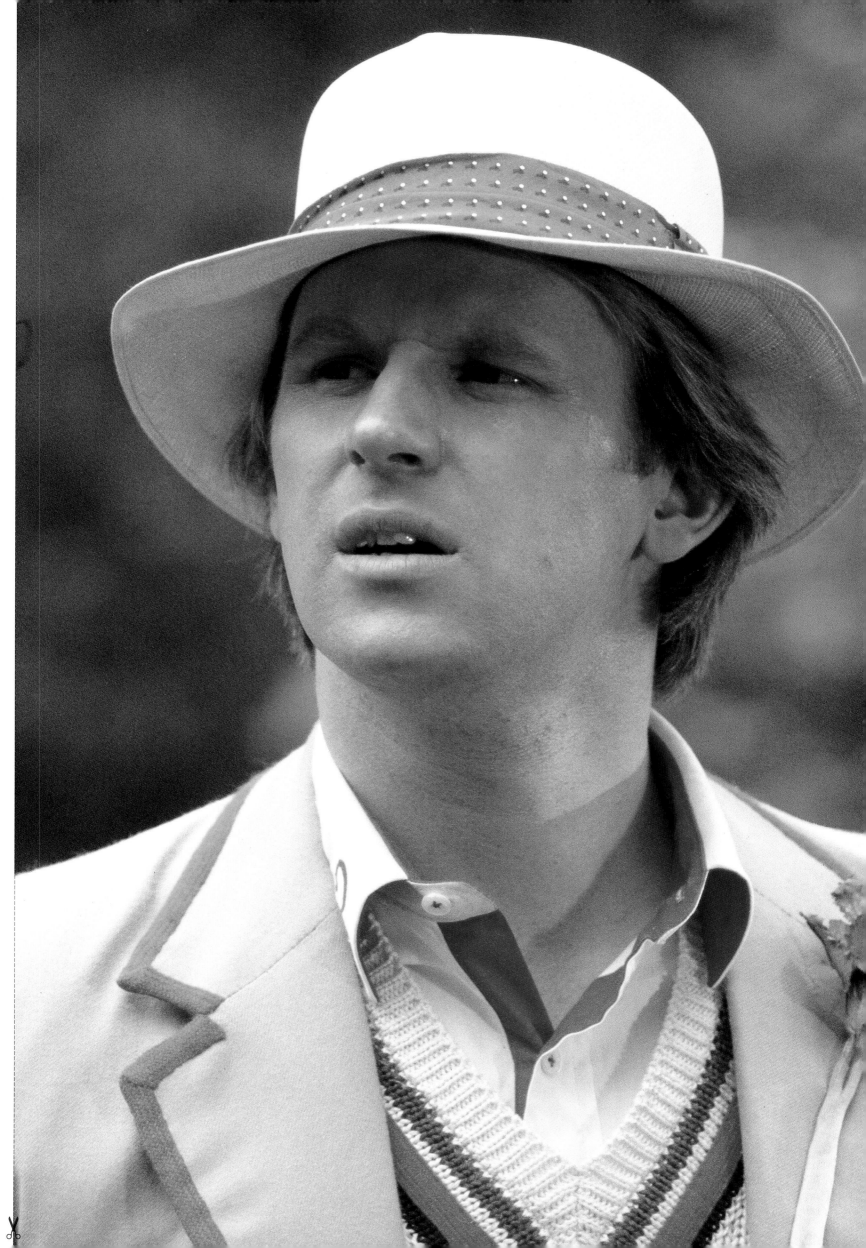

Doctor Who - The Visitation

Peter Davison as the fifth Doctor, exploring the surrounding
forest that the TARDIS has landed in, unaware that both he and
his companions are on Earth in the 17th Century, at the time of
the great plague.
Originally broadcast February 15th - 23rd 1982.

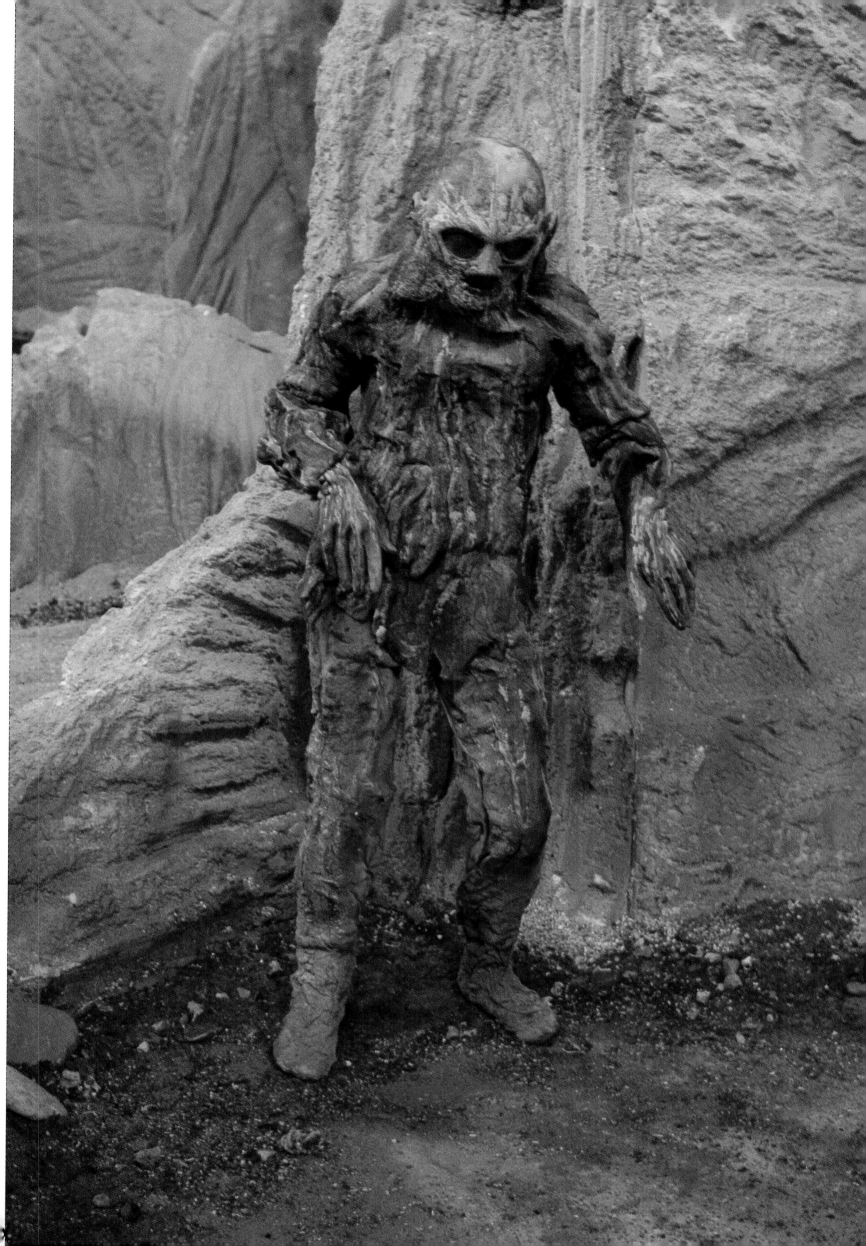

Doctor Who - Death to the Daleks

Arnold Yarrow as Bellal, one of the civilised members of Exxilon society on the planet of the same name. The tiny creature helps the Doctor gain access to the planet's hi-tech city, known as one of the 800 wonders of the universe.
Originally broadcast February 23rd - March 16th 1974.

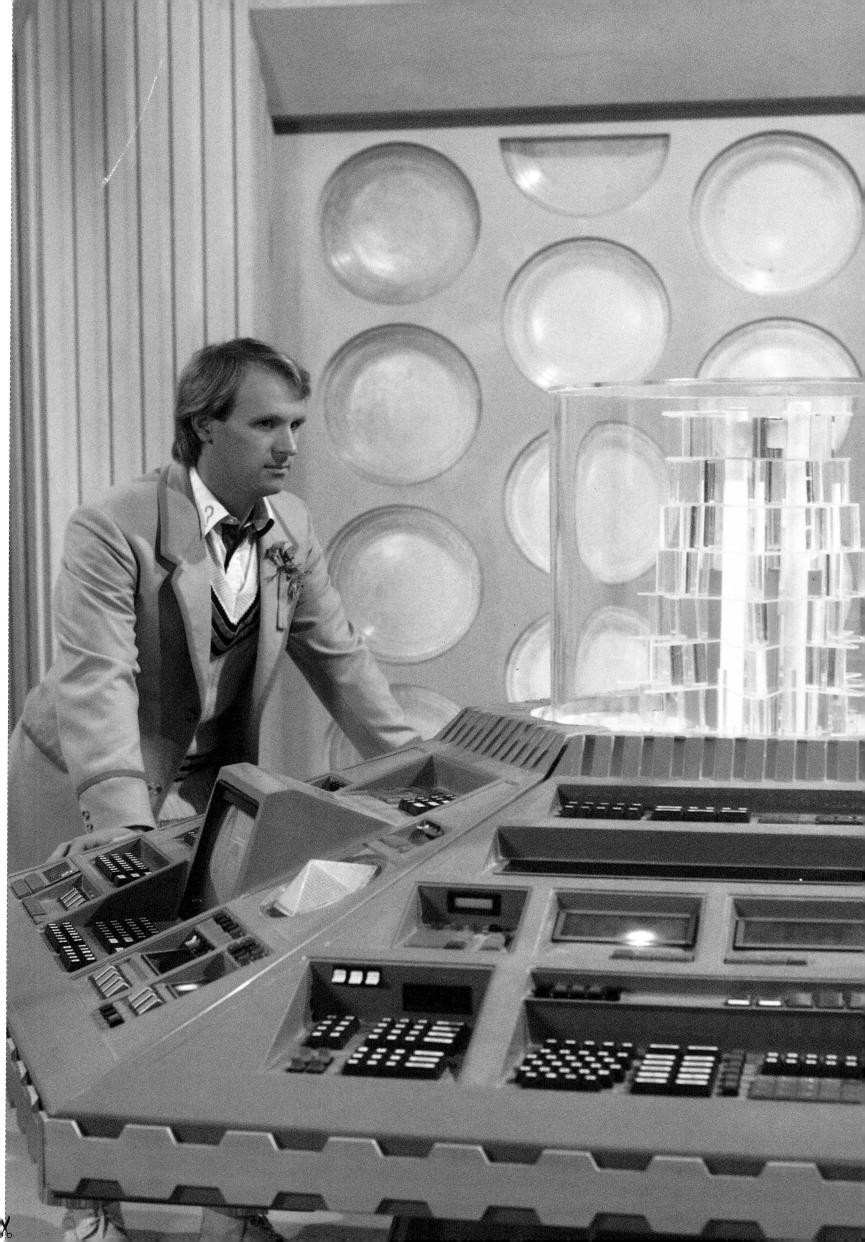

Doctor Who - Planet of Fire

Peter Davison as the fifth Doctor at the TARDIS control console,
which was updated and redesigned for the 20th Anniversary
story, *The Five Doctors*. *Planet of Fire* featured foreign location
filming in Lanzarote.
Originally broadcast February 23rd - March 2nd 1984.

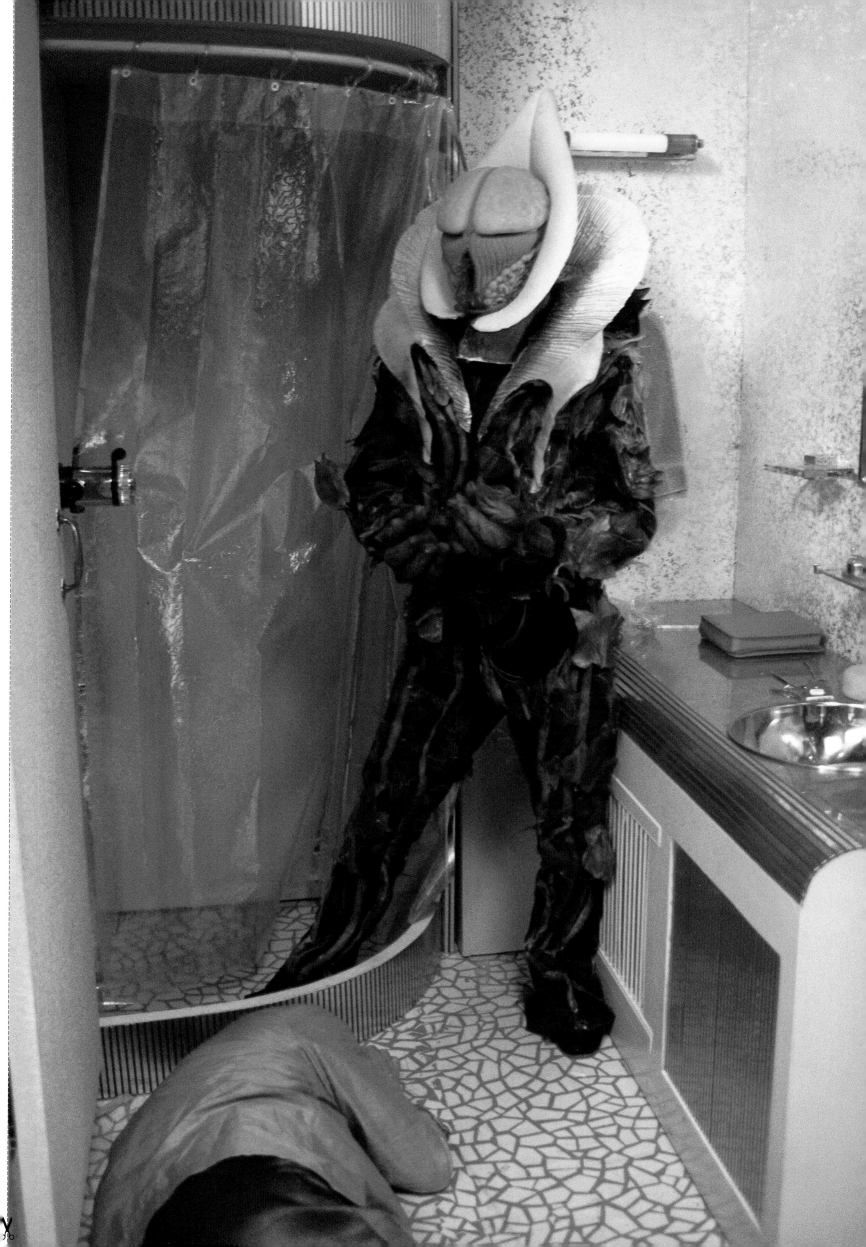

Doctor Who - The Trial of a Time Lord
(episodes 9 - 12)

A Vervoid hides in the shower cubicle of one of the passenger's
cabins on board the space cruiser, Hyperion III. Intent on killing
all humans, the Vervoids were genetically engineered by Profesor
Lasky, who was killed by her creations.
Originally broadcast November 1st - 22nd 1986.

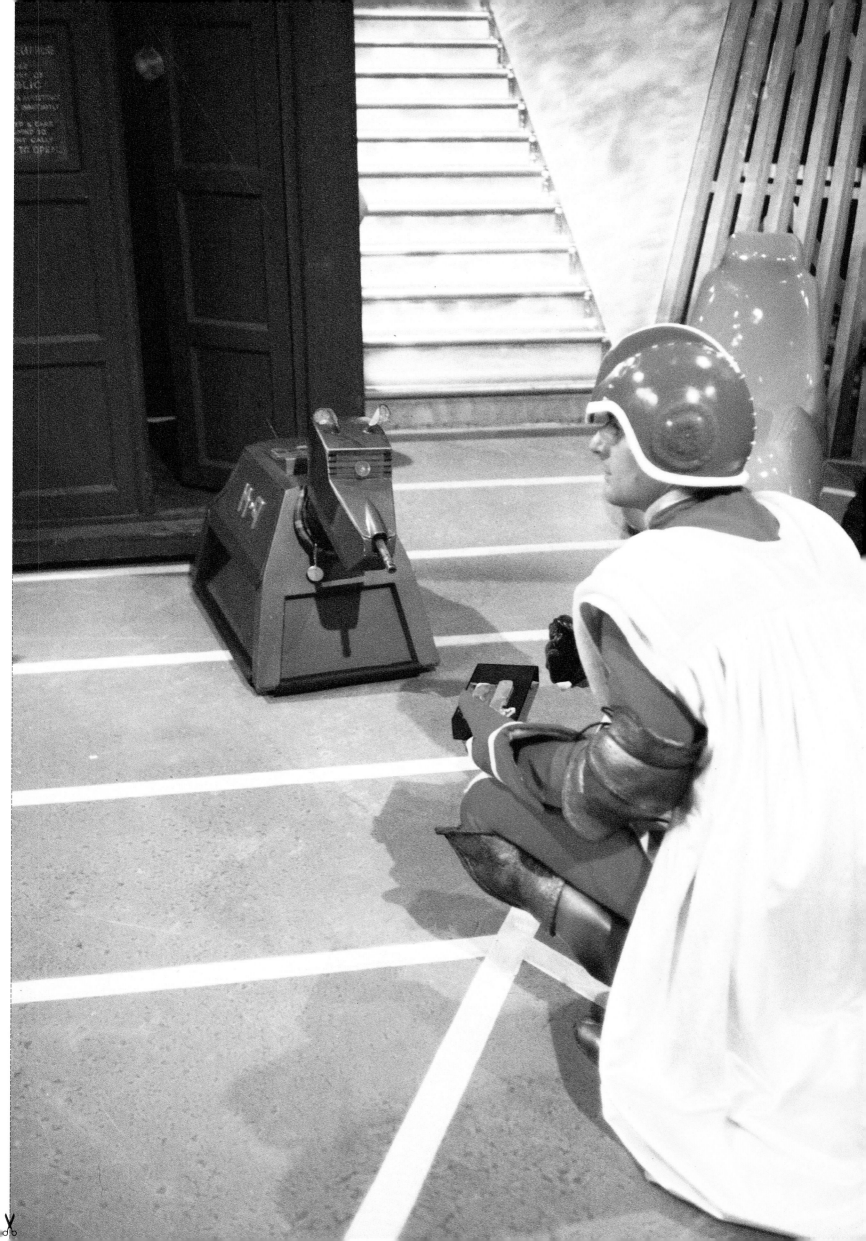

Doctor Who - The Invasion of Time

K9 emerges from the TARDIS in search of the Doctor, who has returned to his homeworld of Gallifrey, and is confronted by one of the Chancellery Guards, left to keep watch on the vessel. This was the last appearance of the original K9, with the Doctor construcing a Mark II version after this version chose to stay on Gallifrey.
Originally broadcast February 4th - March 11th 1978.

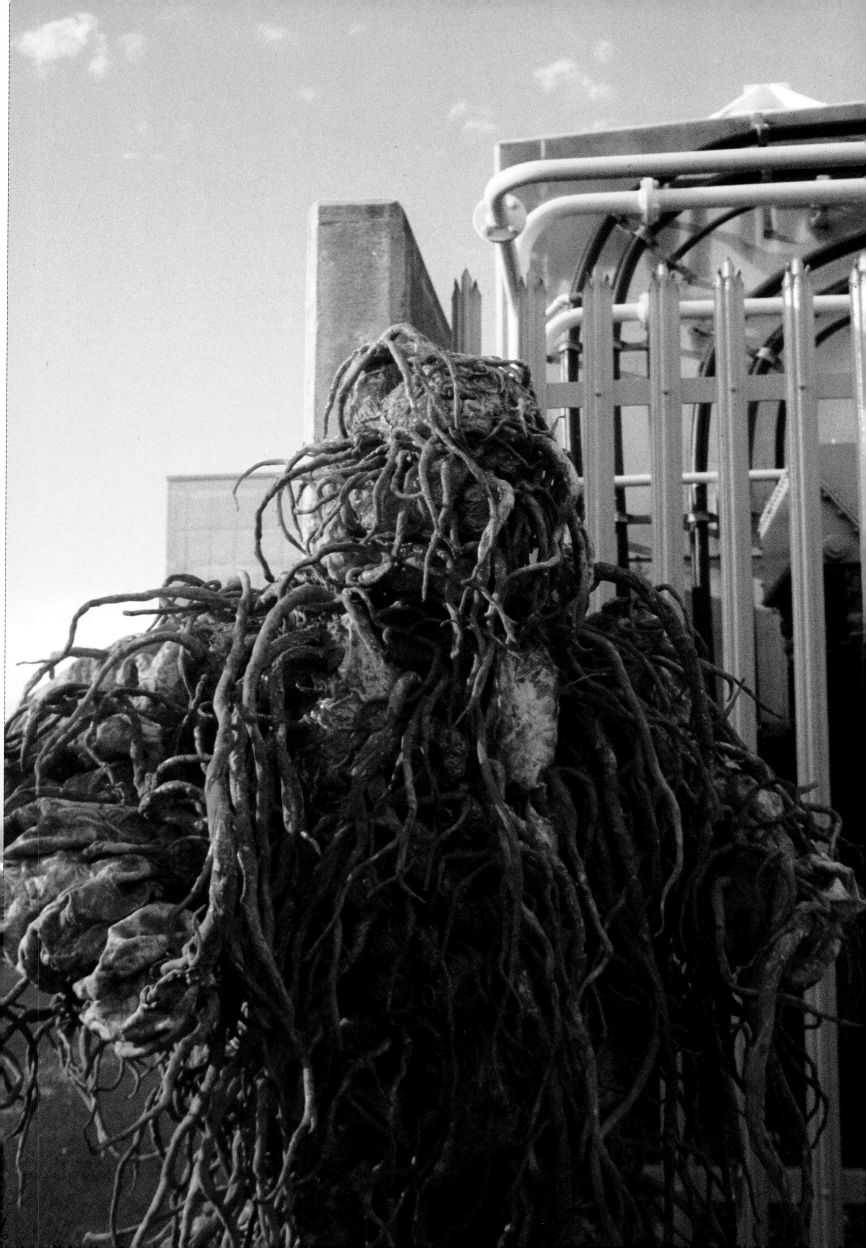

Doctor Who - The Claws of Axos

One of the Axons reverts to its natural form in the grounds of the
Nuton Power Station. The location used by the production team
for these sequences was Dungerness Power Station in Kent.
Stuntman, Stuart Fell played the Axon creature seen here.
Originally broadcast March 13th - April 3rd 1971.

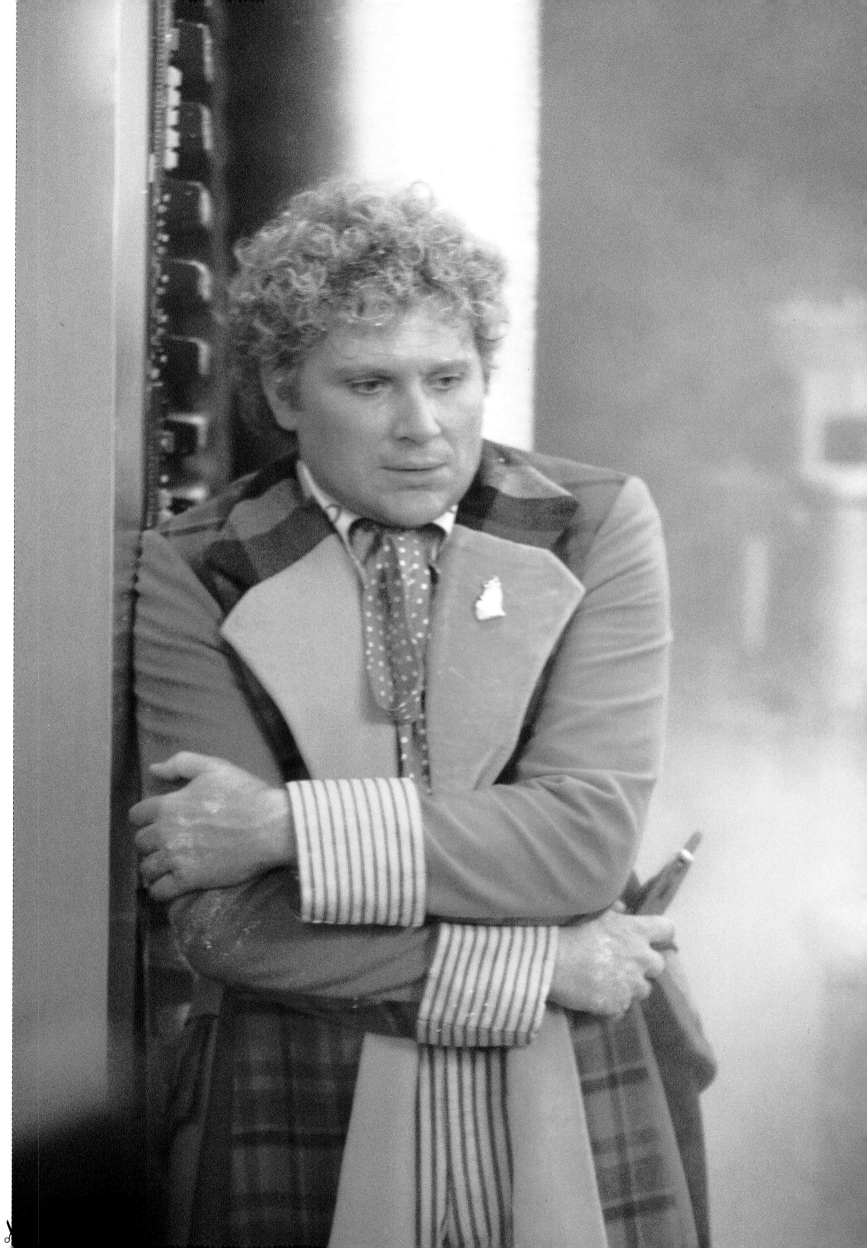

Doctor Who - Attack of the Cybermen

Colin Baker as the sixth Doctor, trapped in one of the cold store rooms on the planet Telos, in the heart of the vast Cybermen tombs there. The story was a sequel to the 1967 Patrick Troughton story, *The Tomb of the Cybermen*.
Originally broadcast January 5th - 12th 1985.

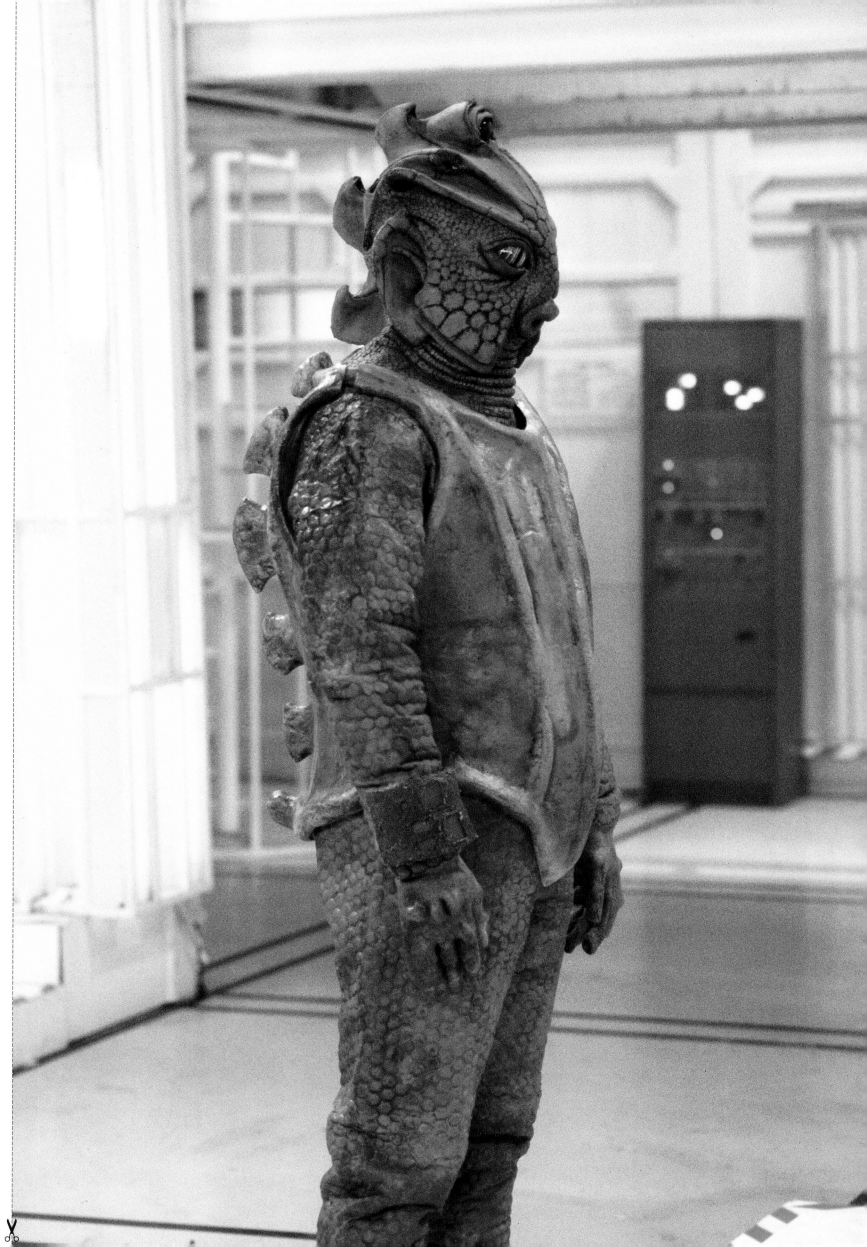

Doctor Who - Warriors of the Deep

Norman Comer as Icthar, one of the Silurian Leaders who invade
Sea Base Four on Earth, in the year 2084, and plan to use its
missile to wipe out mankind. The creatures originally appeared
in *Doctor Who and the Silurians* in 1970.
Originally broadcast January 5th - 13th 1984.

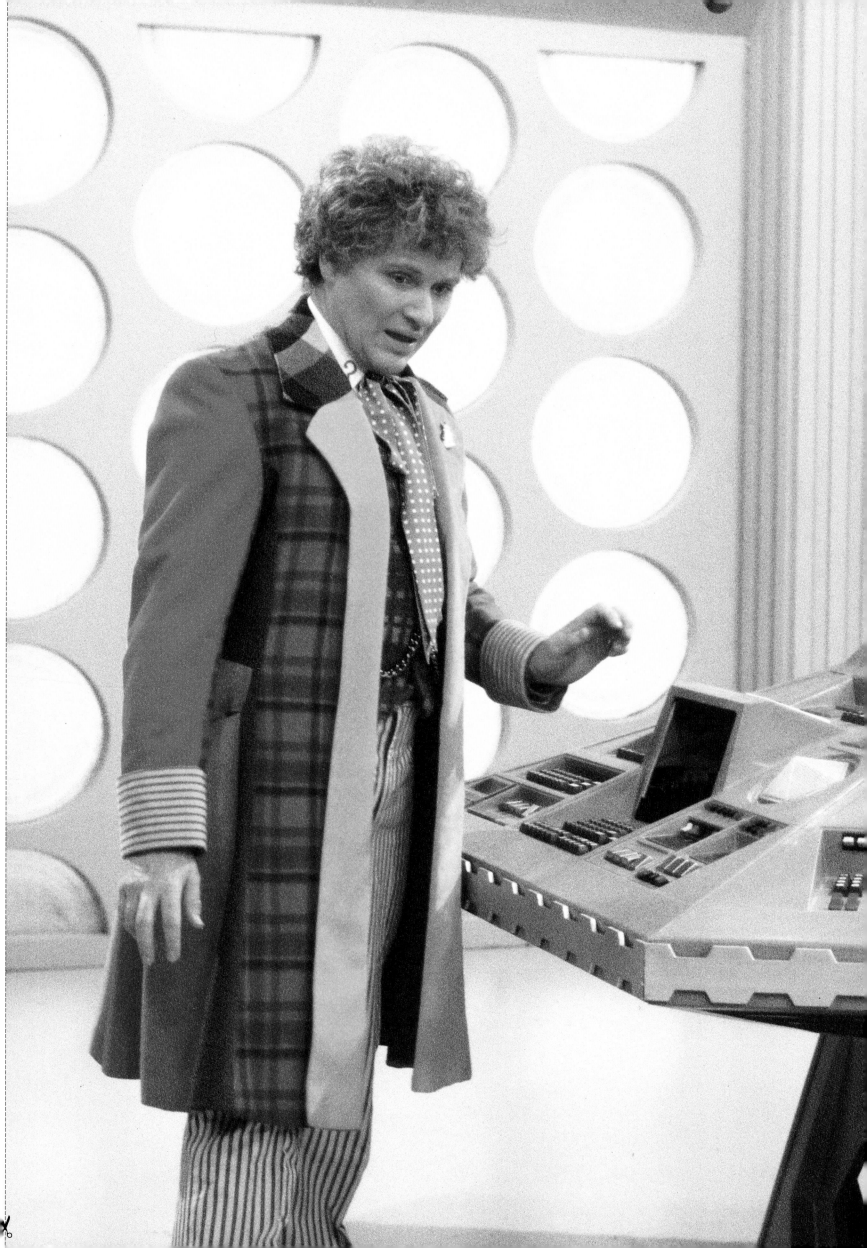

Doctor Who - The Twin Dilemma

Colin Baker as the sixth Doctor at the controls of the TARDIS
console, in his debut story after taking over from Peter Davison
in the role.
Originally broadcast March 22nd - 30th 1984.

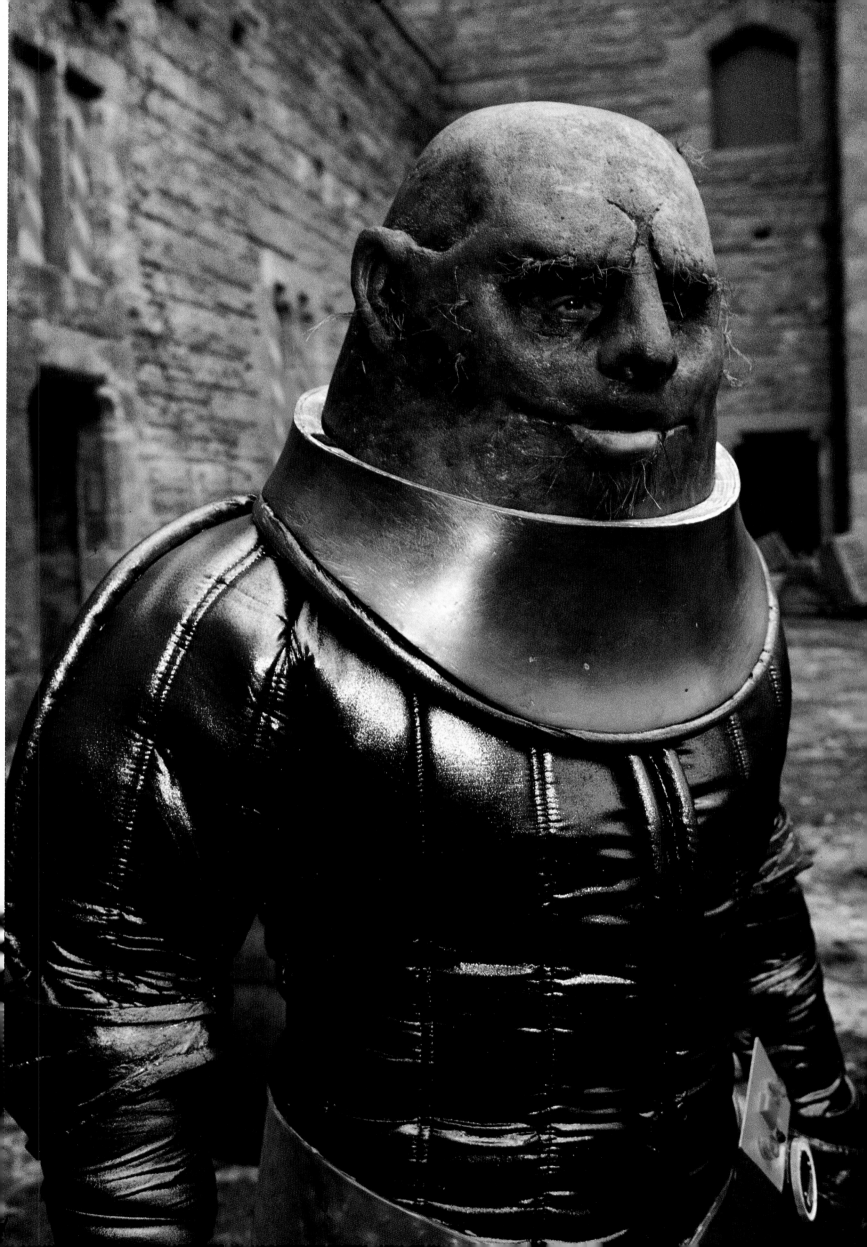

Doctor Who - The Time Warrior

Kevin Lindsay as Linx, the Sontaran warrior stranded in medieval England, using his advance technology to kidnap scientists from the future to help him with repair work on his damaged space craft.
Originally broadcast December 15th 1973 - January 5th 1974.

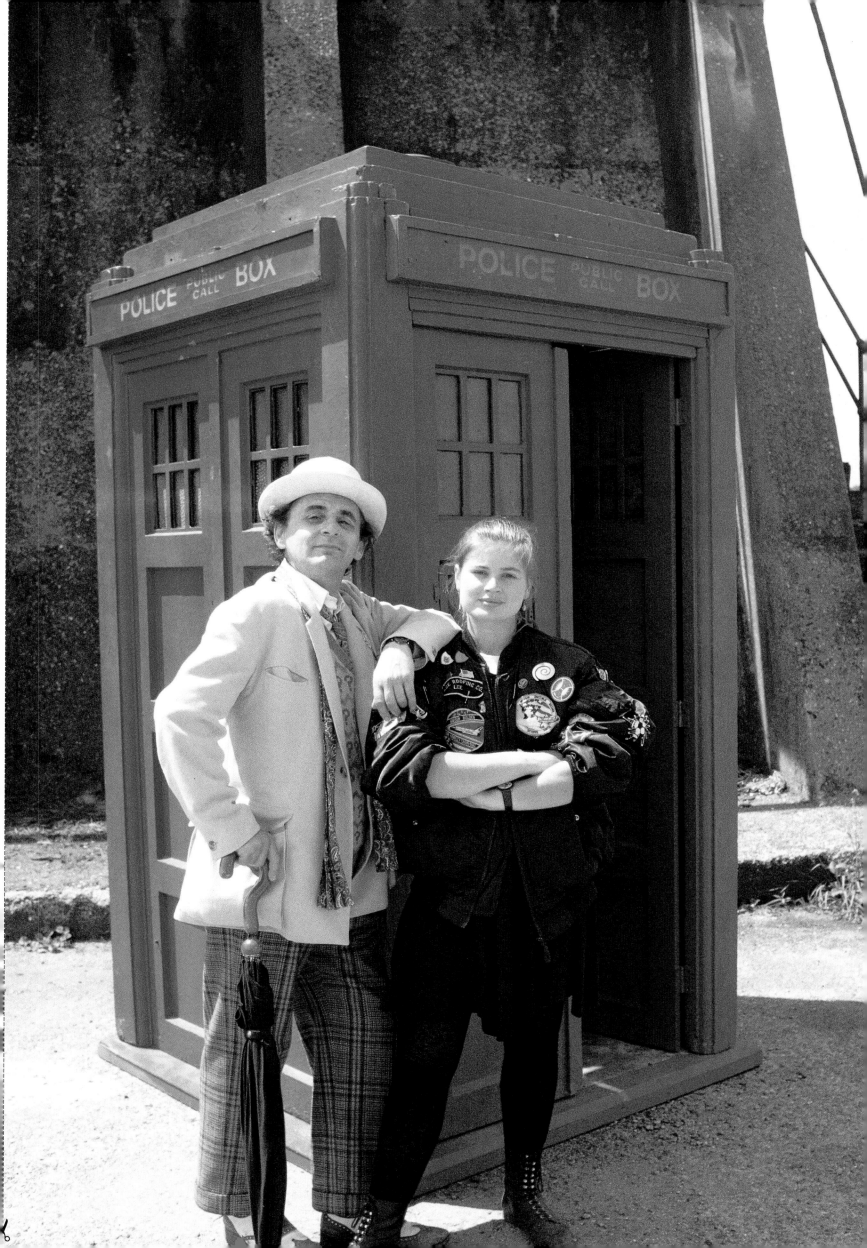

Doctor Who - Silver Nemesis

Sylvester McCoy as the seventh Doctor, with Sophie Aldred as his travelling companion, Ace. The story marked the 25th Anniversary of the programme with a return appearance by the Cybermen. The actors are seen here on location in Greenwich. *Originally broadcast November 23rd - December 7th 1988.*

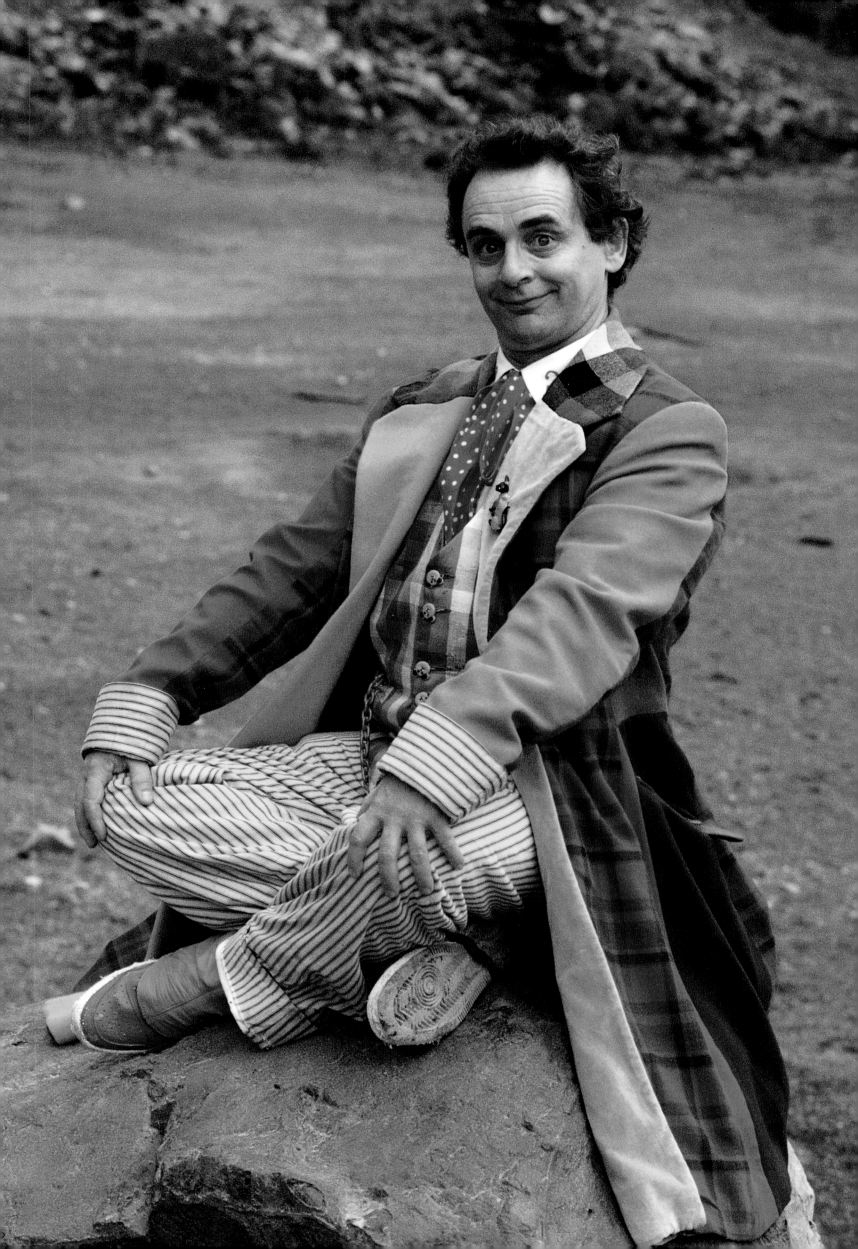

Doctor Who - Time and the Rani

Sylvester McCoy making his debut as the seventh Doctor, on location in one of the quarries used for the story in Frome near Somerset. For the initial scenes of the adventure, the newly regenerated Doctor wore the slightly baggy clothes of his predecessor, the sixth Doctor.
Originally broadcast September 7th - 28th 1987.

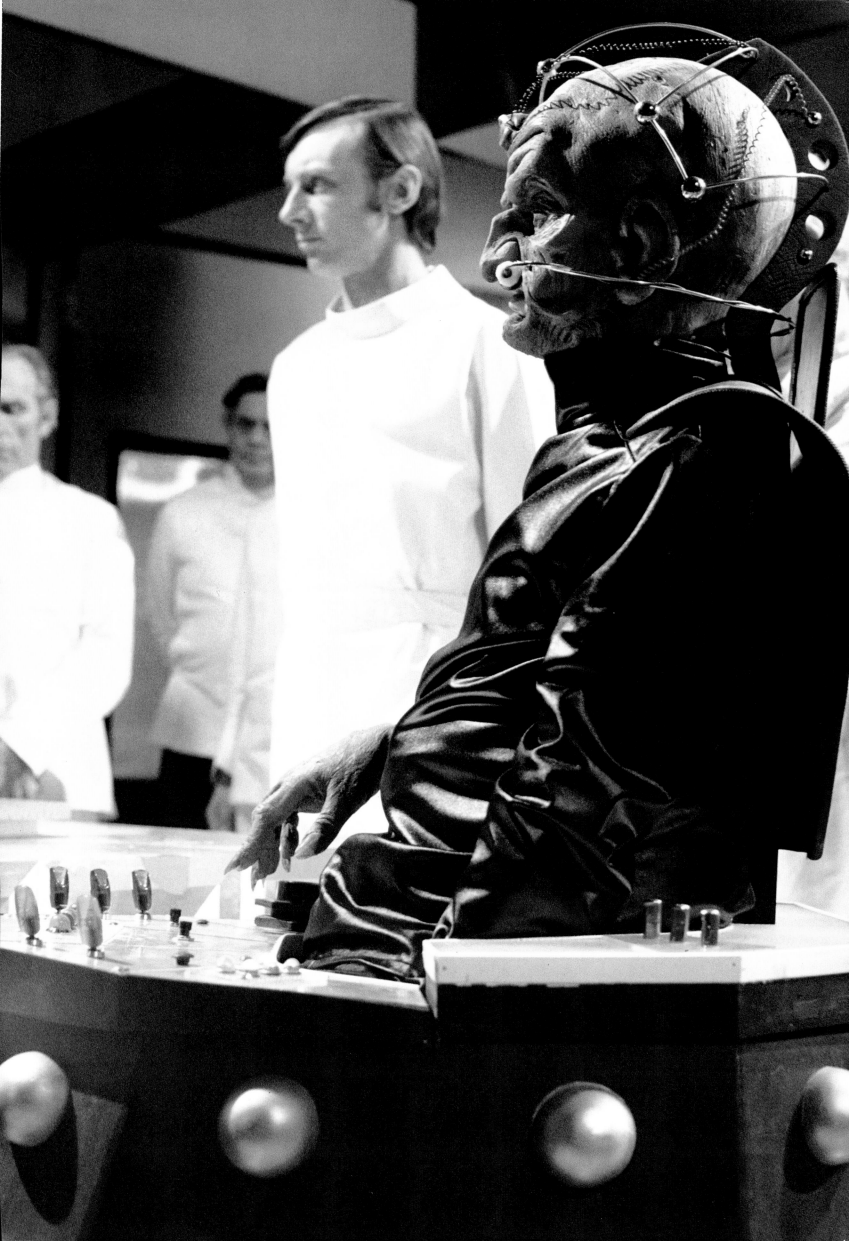

Doctor Who - Genesis of the Daleks

Michael Wisher as Davros, in the first of the character's battles
with the Doctor. Davros would go on to appear in all four of the
subsequent Dalek stories to date.
Originally broadcast March 8th - April 12th 1975.